IMAGES
of America

ALBANY

Don Rittner

ARCADIA
PUBLISHING

Published by Arcadia Publishing
Charleston SC, Chicago IL, Portsmouth NH, San Francisco CA

Printed in the United States of America

Library of Congress Catalog Card Number: 99068847

For all general information contact Arcadia Publishing at:
Telephone 843-853-2070
Fax 843-853-0044
E-mail sales@arcadiapublishing.com
For customer service and orders:
Toll-Free 1-888-313-2665

Visit us on the Internet at www.arcadiapublishing.com

Dedicated to John R. Wolcott.

*Recognition for his lifelong effort to preserve Albany's
natural and human history is long overdue.*

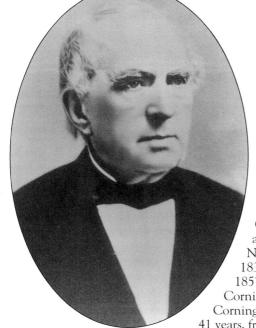

ERASTUS CORNING (1794–1872). Probably
no other family has had as much influence on
the shape of Albany's development as has the
Corning family. Erastus Corning, a financier
and railroad and iron baron, was president of the
New York Central, mayor of Albany from 1834 to
1837, state senator in 1841, and congressman from
1857 to 1859 and from 1861 to 1863. His son Erastus
Corning Jr. carried on the tradition, as did Erastus
Corning II (1909–1983), who was Albany's mayor for
41 years, from 1942 to 1983.

IMAGES
of America

ALBANY

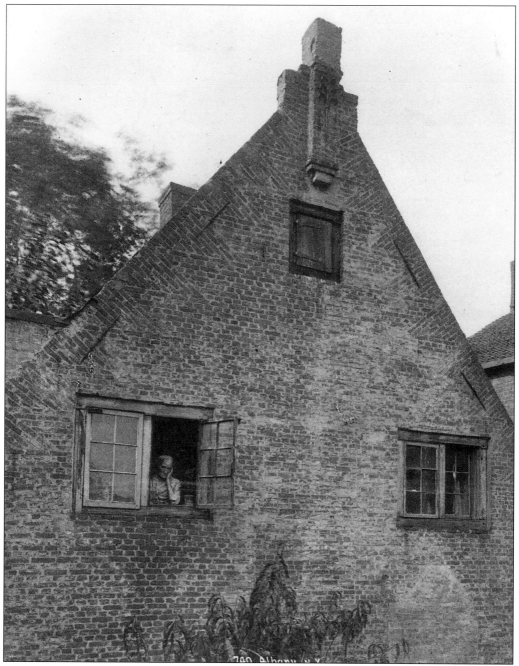

DUTCH HOUSE. This early photograph shows an excellent example of an Albany Dutch house, with an open window where a woman, leaning on her elbow, looks out. (Frances Loeb Library, Graduate School of Design, Harvard University.)

CONTENTS

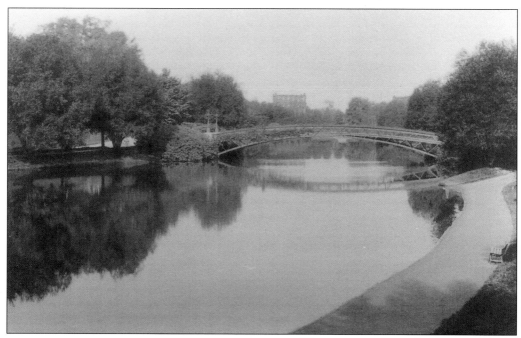

WASHINGTON PARK LAKE, 1897.
Albany is surrounded by natural
beauty. This 351-year-old community
is bounded by the Hudson River on
the east, the Pine Barrens on the west,
Patroon's Creek on the north, and
Normans Kill on the south. On a
clear day, you can see the Helderbergs,
Catskills, Adirondacks, and Green
Mountains of Vermont from any
high point. At one time three Kills
ran through the center of the city.
Over the years Albany has often
treated its natural and human history
with contempt.

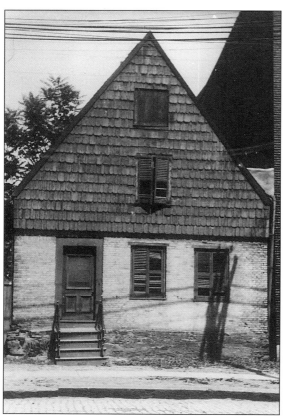

HOUSE OF THE COLONIE. This house
was located on the western side of
Broadway and Pleasant Street in the
neighborhood known as "the Colonie."
The Colonie was Albany's first suburb,
according to historian John Wolcott.
It consisted of land just outside the
city and was the first village inside
Rensselaerwyck. The shingles that
covered the gable end of the house
were a new twist to New Netherlands
architecture—they did not occur in
the Netherlands. The house is gone.

INTRODUCTION

Albany, city of my birth! Ancient, yet new! Replete with interesting associations of the past, connected by so many links with the present, and promising to posterity a glorious future. Thy antique dwellings have been leveled, not so much by the ruthless hand of Time, as the merciless spirit of **improvement.**

Goths and Vandals! Ye were the sweet dispensers of the charities of life, compared to the demon who now stalks abroad under that abused name.

Where now are the palaces of the Knickerbockers and the Van Winkles? Gone! Leveled with the dust, or oh! Worse, **far** *worse, modernized!*

Why the very Holland bricks—if they could speak, would cry **shame**! *And the substantial beams fall down and crush the walls in their deep despair, when they are subjected to the degrading process of* **modernizing***!*

Shades of our fathers! Why is it permitted? To **renovate,** *to* **preserve** *those remnants of the past, should be our pious aim, not with profane hands to cut, hew down, and alter the roof trees which have sheltered generation after generation.*

—The Monthly Rose, Albany Female Academy, 1845.

The city of Albany is located in the Hudson Valley about 150 miles north of New York City in the state of New York. The community was settled in 1648 but was preceded by fur-trading operations that began in 1614, shortly after Henry Hudson discovered the river that bears his name in 1609.

The Dutch first knew the area as *Maykans Landt,* or "land of the Mahicans," the Algonquin-speaking Native Americans who occupied the Hudson Valley prior to the Europeans. Trading posts were established at Fort Nassau in 1614 and Fort Orange in 1624 prior to the founding of a permanent community called the Fuyck in 1648. Fuyck became the city of Albany in 1686. During the 17th and 18th centuries, Albany grew into one of the most important trade, transportation, and military regions in North America.

Albany is where the Plan of Union, the predecessor of the Declaration of Independence, was created by Benjamin Franklin and others in 1754, at the urging of the League of the Iroquois. Albany was the headquarters and home of military leaders who played a pivotal role in the French and Indian and Revolutionary Wars. It was a staging area for many battles.

In 1797, Albany became the permanent capital of New York State and went on to become a major political center, helping to shape New York's growth and prosperity.

Albany-born natives and those calling Albany home also have played a role in the national arena over the last three centuries. Many of them became leading statesmen, scientists, and

even presidents. They include Philip Livingston, delegate to the Continental Congress in 1775 and signer of the Declaration of Independence, 1776; Nathaniel Paul, 1775?-1839, a black abolitionist, the minister of the first black church in Albany, called the African Baptist Church, and one of the founders of a settlement for escaped slaves in Canada; Martin Van Buren, governor in 1829 and U.S. president from 1837 to 1841; Joseph Henry, the inventor of the telegraph in 1831 and the first director of the Smithsonian in 1846; James Hall, the father of American geology, 1836; Harmanus Bleecker, the ambassador to the Netherlands in 1839; Hamilton Fish, governor from 1849 to 1851 and U.S. secretary of state from 1869 to 1877; William McKinley, graduate of Albany Law School and president from 1897 to 1901; Theodore Roosevelt, governor from 1898 to 1900 and president from 1901 to 1909; William Cox Redfield, U.S. secretary of commerce from 1913 to 1919; and Franklin Delano Roosevelt, governor from 1929 to 1932 and president from 1933 to 1945.

A history encompassing 385 years cannot be written in two pages and will not be attempted here. For more detailed information about the history of Albany the reader is directed to *History of the City of Albany, New York,* by Arthur Weise (1884) or *Landmarks of Albany County,* by Amasa J. Parker (1897). A more recent overview can be found in John J. McEneny's *Albany: Capital City on the Hudson* (American Historical Press, 1998).

Nonetheless, as old as Albany is, it continues to wreck the very foundation of its claim to history. Albany has had an antagonistic relationship with its history. It has not gone unnoticed, either. Over the last three centuries, visitors and residents have written about Albany's lack of concern for preserving its history, a fact that unfortunately continues today. City leaders often have failed to realize that by not embracing the past, they are floating in the middle of the ocean without compass or rudder. If you cannot determine where you came from, you cannot steer ahead to your rightful future.

Over the last several years, while other old cities have embraced their archaeological and historical treasures, Albany has watched as eight construction projects have unearthed various parts of its history. Rather than trying to preserve these remnants of one of the oldest communities in the United States, Albany has allowed them to simply be swept aside—destroyed in the name of progress.

In 1970, archaeologists uncovered the original site of Fort Orange. It was buried by an exit ramp for a new highway interchange. In 1999, archaeologists uncovered 170 feet of Albany's stockade, the protective wall around the city. It was buried again—with piles driven through it—and turned into a parking garage for State University of New York employees. A local news reporter described a tour of Albany's archeological sites as worthwhile only if you bring an "active imagination" because you cannot see anything.

This book is a photographic essay of Albany's 19th- and early-20th-century history. Albany's 17th and 18th centuries are archeological resources waiting to be rediscovered as there are few standing structures left to point out.

More than 200 photographs have been selected and arranged in this book focusing on Albany's historic downtown area. By using this book as your field guide, you can visually trace the changes that have occurred over time. You will see an Albany full of architectural treasures, several of which still exist. With a good imagination you can even hear the sounds of a bustling city with the clamor of horses and wagons and streetcars going up and down State Street or the blowing horns of steamboats as they ply up and down the Hudson River.

Albany is unique. It is entering its fourth century as an American community while entering a new millennium surrounded by natural beauty and a rich human legacy second to none. Albany's future is the past, and citizens should insist that its leaders preserve and protect these resources. Heritage tourism will likely become a $200-billion industry in the United States by the year 2005. Albany is a heritage destination that everyone, young and old, can enjoy.

The city of Albany still has a long story to tell with an abundance of resources, both above and below the ground, that need to be explored. With a coordinated plan of action involving state, local, and citizen participation, we can uncover and appreciate Albany's undiscovered

city for years to come. To borrow a line from Socrates: "The only good is knowledge and the only evil ignorance."

I would like to extend my sincerest appreciation to Ellen K. Gamache, local history librarian at the Albany Public Library for her assistance and permission to use photographs from the Pruyn Library of Albany History, which appear throughout this book. I also wish to express my appreciation to my old friend Morris Gerber, who gave me permission to use several photographs from his "Old Albany" series, published in the 1960s as an early promotion of Albany's history. I wish to thank Tricia Barbagallo for her work on the dating of the Albany collection. Special thanks go to my friend and mentor John Wolcott for making sure that I got the facts right in each of the captions. Any errors, however, are my own.

—*Don Rittner*

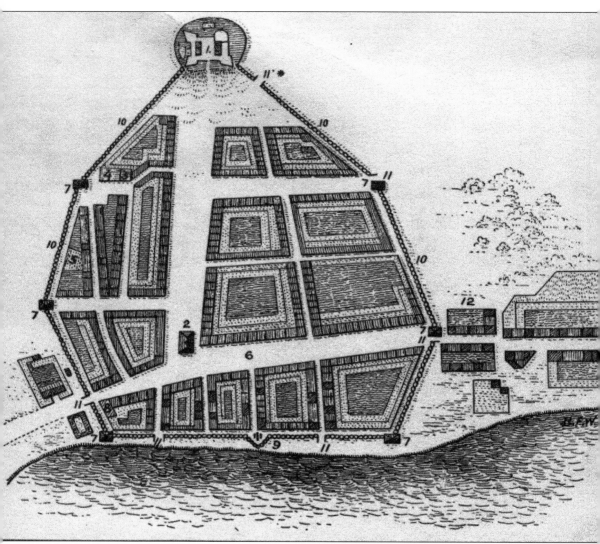

MAP OF ALBANY, 1695. This map was prepared in 1695 by John Miller, a chaplain in the British army. A defensive wall of planks and posts was built around Albany in 1659. Beginning in 1671, a stockade consisting of pitch pines or oak was erected. The stockade was abandoned at the end of the French and Indian War in 1763. Parts of it have been unearthed during excavations in the city but these have routinely been reburied or destroyed. An Albany Irishman who dug up some of the stockade posts in the 19th century presented them to the common council to help start an Albany museum. Where are they today?

One

THE CHANGING STREETSCAPES OF

DOWNTOWN ALBANY

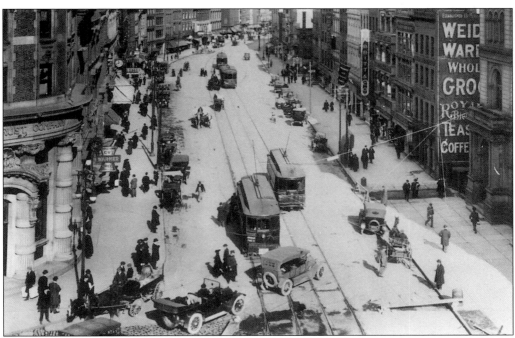

BUSY BROADWAY. This view of Broadway was taken looking north from the corner of State Street. Notice cars, wagons, and trolleys fighting for the right of way. Cars won the battle. In 1861, 113,919 people called Albany home. In the decade that ended the 19th century, Albany had about 95,000 people. As the 20th century ended, the city had a population that was not much bigger, having lost some residents to the suburbs.

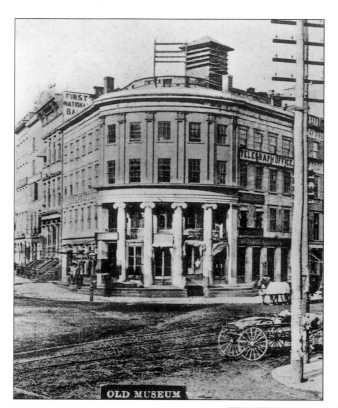

OLD MUSEUM

THE ALBANY MUSEUM. From December 1, 1830, to April 28, 1855, the Albany Museum was located on the northwest corner of State Street and Broadway, known as the Johnny Robinson Corner. The museum first opened in December 1797 on the corner of Green and Beaver Streets and later moved to the third floor of city hall. Its final home was this structure built by Thorp & Sprague, initially called the Marble Column Building and later known as the Museum Building. It contained "a number of living animals, and a great variety of other natural and artificial curiosities." Light illumination by gas inside a building was first demonstrated here on March 22, 1817. Albany's streets were first lit with gas on November 10, 1845.

THE ALBANY EXCHANGE. The Albany Exchange was located on the northeast corner of State Street and Broadway, opposite the Albany Museum. The Exchange formed on May 30, 1827, and erected this structure in 1836. It became the National Exchange Bank in 1885 and moved to 458 Broadway. Both the New York Central Railroad and the post office had offices here. Dr. Abram Staat lived here in the 1640s, and behind him on the east was the brewery of Volkert Janse Douw. State Street from Broadway to the river, on the right, was called Abram Staat's Alley in his honor. Later the street was widened and called Little State Street.

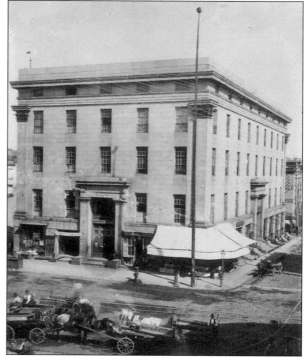

THE MECHANICS AND FARMERS BANK. Located to the north of the Albany Exchange at 6 Court Street, now South Broadway, was the Mechanics and Farmers Bank. To the right is Exchange Street, originally called Mark Lane. The bank incorporated on March 22, 1811, and moved to the beautiful building on the corner of State and James Streets in 1891. The Broadway building was demolished in 1875 to make room for the federal building. Notice the peddler sitting on the crate next to the billboard.

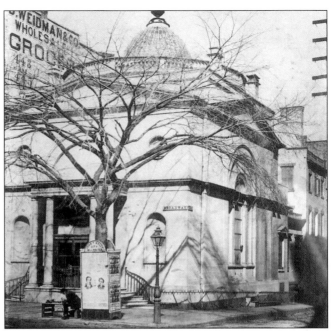

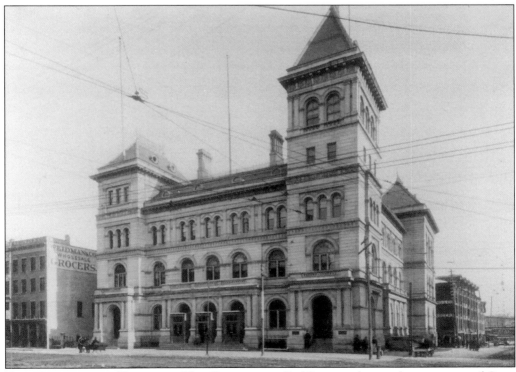

THE GOVERNMENT BUILDING. The Government Building on the northeast corner of State Street and Broadway was first occupied in December 1883. Both the Mechanics and Farmers Bank and the Exchange Building were demolished in 1875. The site was occupied by the post office on January 1, 1884.

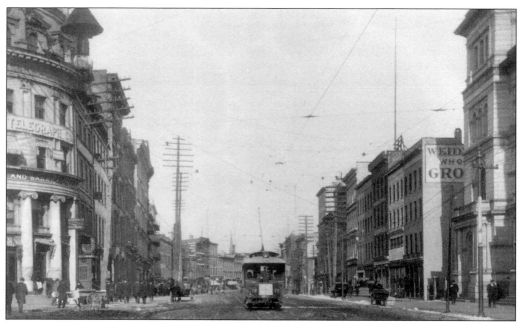

STATE AND BROADWAY, 1897. This view of the east side of State Street and Broadway was taken in 1897, looking north. Electric trolley No. 72 is visible in the center. The first horse-drawn trolleys appeared on Broadway on June 22, 1863. They ran from the lumber district to the south ferry, now Ferry Street.

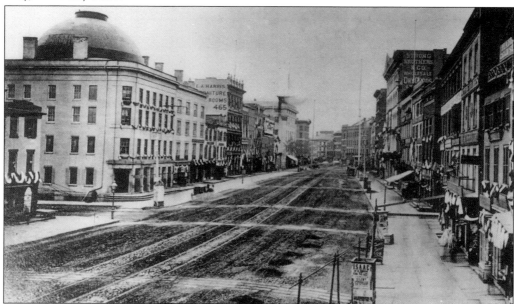

A VIEW OF BROADWAY, 1863. This view of Broadway was taken in 1863 looking south. Stanwix Hall, later the Stanwix Hotel, is the domed structure on the left at the intersection of Maiden Lane. Built in 1833, the Stanwix is now gone, as are most of the buildings seen here. On February 1, 1865, a span of horses ran away on Broadway, tossing the driver and killing a woman.

STANWIX HALL. Here is a close-up of Stanwix Hall at the southeast corner of Broadway and Maiden Lane. The Stanwix was a leading hotel for years, competing with the Delavan down the block. It was built in 1833 by the son of General Gansevoort, the hero of Fort Stanwix. On June 4, 1867, L. Harris Hiscox, a member of the constitutional convention, was shot here by Gen. George W. Cole.

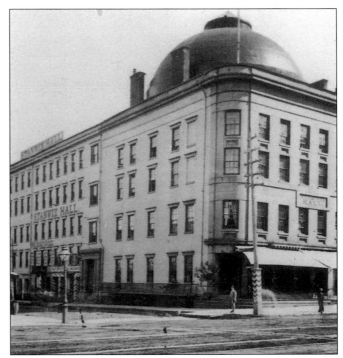

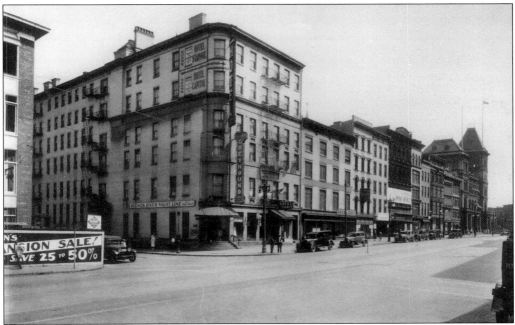

BROADWAY AT MAIDEN LANE, c. 1932. This view of Broadway at Maiden Lane was taken c. 1932 looking south. The Stanwix Hotel dome has been removed and some additions have been built. Tickets for the Hudson River Night Line and Greyhound bus were available at the hotel. This building and eight others up to the post office building were demolished to make room for the current post office building.

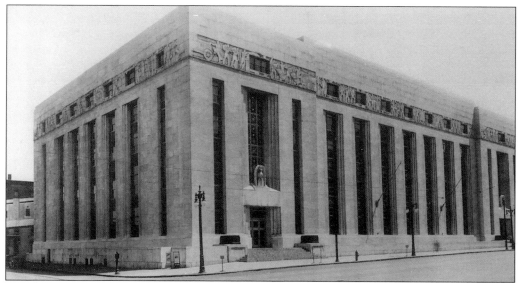

THE POST OFFICE, 1947. Here is the current post office building as it looked in 1947. For many years the post office was housed in the Exchange Building. This new building was erected in 1933. Behind the building archaeologists, in 1999, uncovered 170 feet of the Albany Stockade, which protected citizens during the 17th and 18th centuries. Also unearthed were parts of the Albany Basin, the wharf from which departed the *Experiment*—the Hudson River sloop that in 1784 became the first to go to China—and a possible Mohican fishing area. These remains were covered so that a parking garage could be built for the State University of New York.

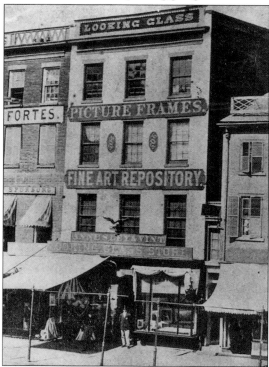

ANNUSLEY & VINT, 1866. The Annusley & Vint Looking Glass Store was located at 506 Broadway, on the west side, across from the post office block. Annusley & Vint also had an art gallery at 57 North Pearl Street. Established in 1802, the gallery was famous for being the "art centre of Albany."

BROADWAY BUSINESSES, 1872. At 520 Broadway, west side, J.W. Fisher sold boots or shoes and Churchill & Dennison took photographs. This photograph dates from 1872.

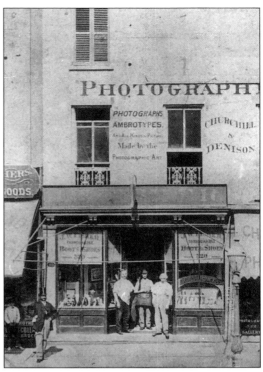

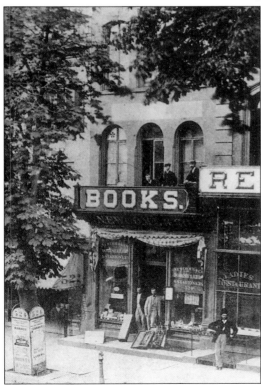

THE T.D. NEWCOMB COMPANY, 1873. The T.D. Newcomb Company sold books and stationery supplies at 524 Broadway, west side. Next door was a restaurant for ladies. This photograph was taken in 1873. The building is still in use.

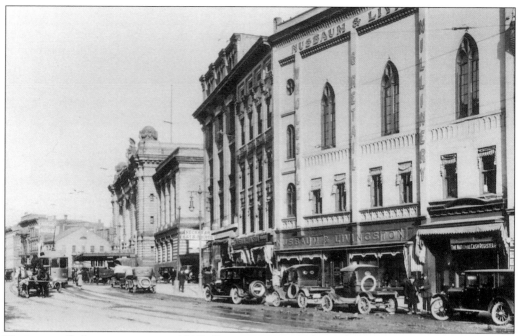

NUSBAUM & LIVINGSTON, c. 1925. Beginning in 1925, Nusbaum & Livingston operated a wholesale and retail millinery at 525 Broadway, east side, between Maiden Lane and Steuben Street. This photograph was taken c. 1925, looking north. The building previously housed the Temple of Music in 1859; the meeting room for the Burgess Corps, the city militia armory; and the publishing house of W.C. Little & Company in 1863. Originally called Bleecker Hall, it was one of the first examples of Gothic Revival-style commercial buildings in the United States. The state dormitory authority building has replaced it.

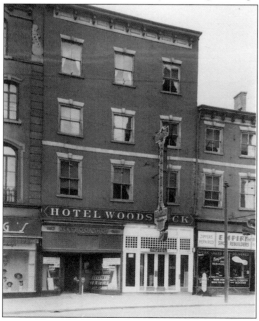

HOTEL WOODSTOCK. Hotel Woodstock was located at 536 Broadway, west side, across from the state dormitory building.

GROVER & BAKER, 1867. The Grover & Baker Sewing Machine Company was located at 519–531 Broadway, west side, across from the dormitory building. The company also rented sewing machines. This photograph dates from 1867. Notice the mannequin next door.

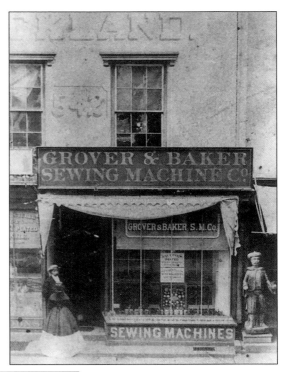

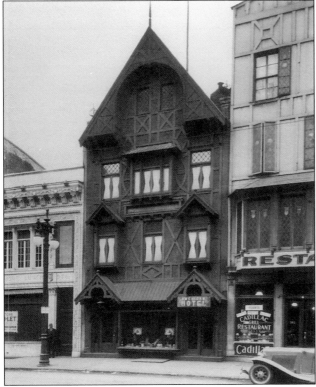

THE AMERICAN OR SCHLITZ HOTEL. The American or Schlitz Hotel was located at 578 Broadway, west side, opposite Union Station. To the left was the Belmont Lunch, and to the right was Keeler's Restaurant.

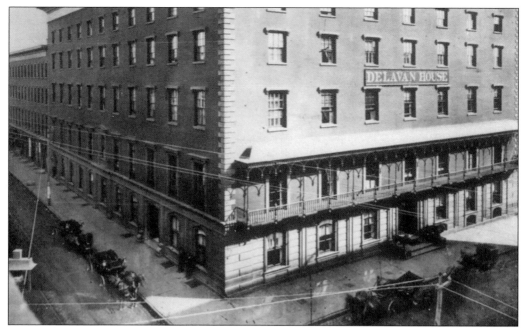

THE DELAVAN HOUSE. The Delavan House was located at the northeast corner of Broadway and Steuben Street. E.C. Delavan, head of the Temperance League of New York State, erected the building in 1844 as a temperance house. Later, the building became a popular hotel for politicians. On its steps in 1847, the first telegraph message by sound was read. Theophilus Roessle, who made his money growing fruit and vegetables in the Pine Bush, took over the hotel in 1849. The building burned on December 30, 1894, in a fire that caused a number of deaths.

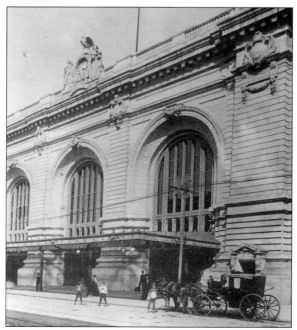

THE UNION DEPOT. The Delavan House ruins were replaced by the Union Depot in December 1900. This station was used by the New York Central and Hudson River, the Boston & Albany, and the Delaware & Hudson Railroads. The station was slated for demolition but was saved by Fleet Bank, which opened offices there. In 1872, an earlier Union Depot was located just south of this one, on Montgomery Street between Maiden Lane and Steuben Street.

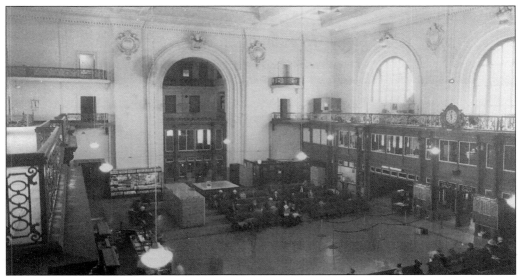

UNION STATION INTERIOR, 1930S. This photograph shows the interior of Union Station in the 1930s. The waiting room was 103 by 134 feet and 50 feet high and included a restaurant. The room was finished in mahogany and quartered oak, and its walls were polished granite. Guy Spataford's grandfather was the barber there.

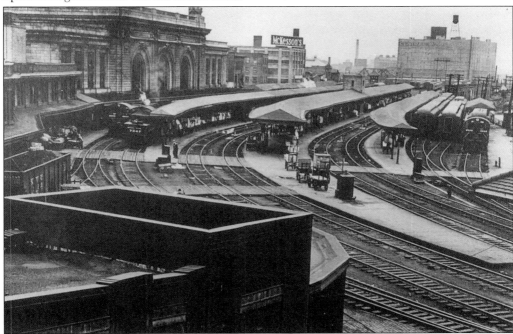

BOARDING TRAINS, 1948. Union Station became a hub for travel around the country and was also the center for local commuter travel between Albany and Troy. Each weekday, more than 30 trains operated by the New York Central and the Delaware & Hudson traveled between Albany and Troy, only 25 minutes apart. On April 5, 1859, New York Central was in court explaining why its engines were going more than 4 miles per hour across Broadway. This 1948 view has been replaced by the Interstate 787 highway system.

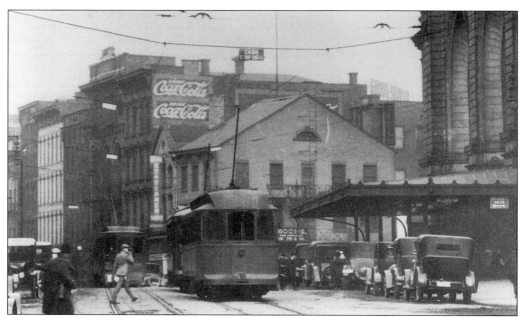

BROADWAY AT UNION STATION. This view shows Broadway in front of Union Station in the first quarter of the 20th century. Notice the trolleys in the middle. The area around the train station was a busy section of the city. Buildings to the left of Union Station are now gone, replaced by a new Department of Environmental Conservation Building.

THE CORNER OF STEUBEN AND BROADWAY, c. 1919. This photograph of the corner of Steuben Street and Broadway was taken c. 1919, looking north. Union Station is to the right and out of sight. Notice that trolleys, cars, and horse-drawn wagons all claim the street. The American Hotel, Belmonts Lunch, and Keeler's are visible near the top. All of the buildings here are gone, and the area is now a park.

THE VANDENBURGH HOUSE. This Dutch house at 674 Broadway was known as the Vandenburgh House. Located between Orange Street and Clinton Avenue, the house was outside the city limits and within Albany's first suburb, "The Colonie." Notice the classic fleur-de-lis Dutch wall ties that held the floor beams to the walls. A 1940s effort to save the house failed.

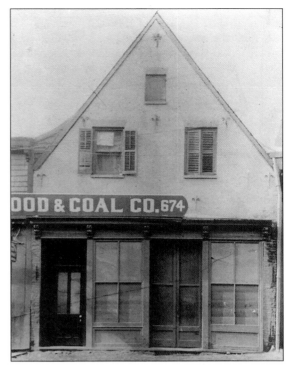

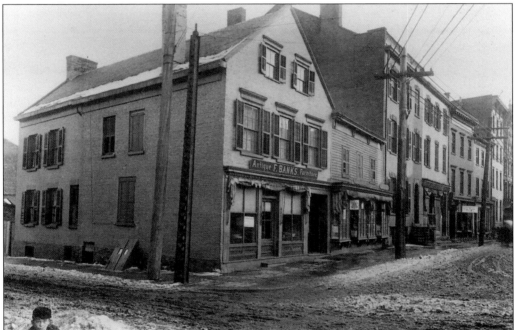

THE QUACKENBUSH HOUSE, 1890. Originally a Dutch dwelling of unknown date, the Quackenbush House was modified during the Federal period. The house was used as a military headquarters during the French and Indians War.. Today, the building is a restaurant and to the right of it is the Clinton Avenue exit ramp off Interstate 787. .The remaining houses are gone.

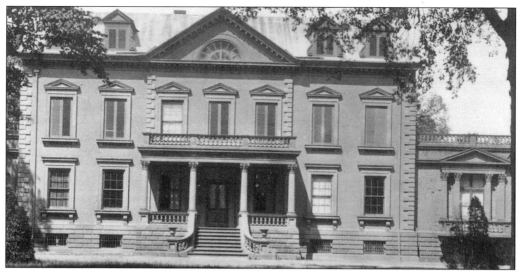

The Manor House. The Manor House was the home of the last patroon, Stephen Van Rensselaer. Erected in 1765, the house was dismantled in 1892 and moved to Williams College to be used as a fraternity house. The site off Manor Street became an industrial region, and an old warehouse built by Rensselaer in 1890 still stands nearby. Albany architect Cuyler Reynolds was a fraternity brother at the college in Williamstown, Massachusetts, and initiated the move. The house was torn down in 1974.

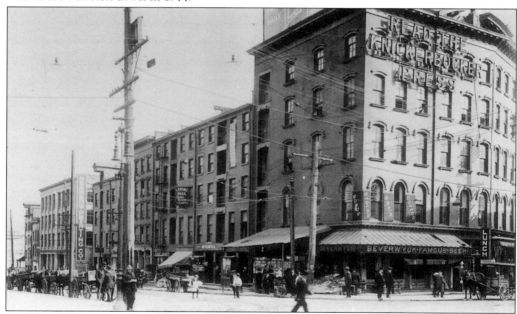

Broadway and Lower State Street, 1914. This photograph shows the southeast corner of Broadway and lower State Street. This was the home of the Knickerbocker Press. The *Knickerbocker,* which is no longer published, became a daily newspaper on September 3, 1843. The *Albany Times-Union* is the city's remaining paper and has been published under that name since it merged with the *Evening Journal* on November 17, 1891. All of the buildings in this view were razed for the D&H Plaza.

BROADWAY, SOUTH OF STATE STREET, c. 1910. This view of Broadway south of State Street was taken c. 1910, looking north. The third structure from the domed First Trust Building may be the modified original Stadts huys, or city hall, at the corner of Hudson Street. Rebuilt in 1743, the building burned in 1836; however, historian John Wolcott believes it could have had much of the original city hall fabric. The New York Legislature met there during the 18th century; and Benjamin Franklin's Plan of Union, the forerunner of the Declaration of Independence, was adopted there in June 1754. All of these buildings are gone, and the site is now part of the D&H Plaza.

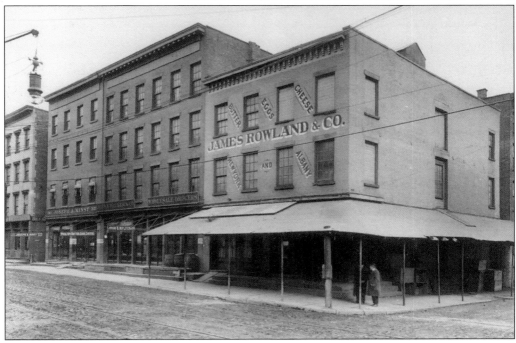

BROADWAY AT DIVISION STREET. This c. 1912 photograph shows 351–367 Broadway at the northeast corner of Division Street. The alley to the left of the third building was called Trotter's Alley. The area is now part of the D&H Plaza.

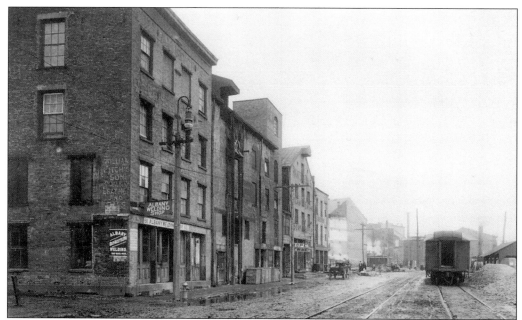

QUAY STREET. This is a view of 66–60 Quay Street, with Trotter's Alley to the left. Quay Street ran the length of the Albany stretch of the Hudson River, which is on the right. Notice the Albany & Susquehanna railroad tracks. On September 30, 1862, the first Albany & Susquehanna engine was put on the tracks, which at the time were only 2 miles in length.

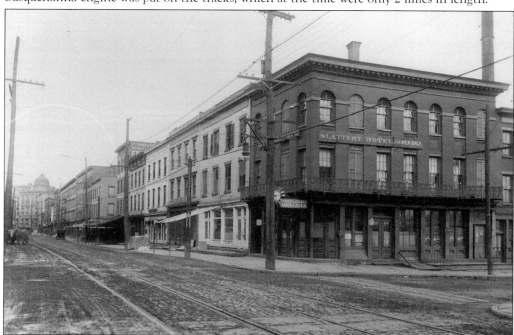

SLATTERY'S HOTEL. This photograph of Broadway between Hamilton and Division Streets was taken from the northeast corner of Division Street. Slattery's Hotel was for men only. All buildings shown here were demolished in 1914 for the D&H Plaza.

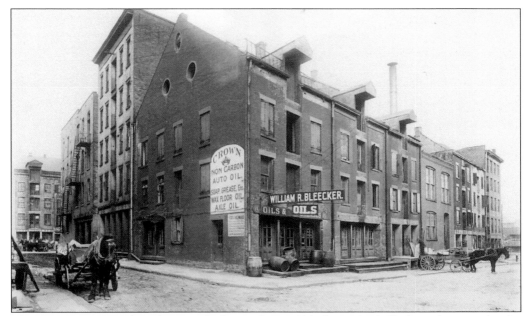

HUDSON AVENUE. This photograph dating from 1900 shows 1–19 Hudson Avenue. At the right, Hudson Avenue connected to Quay Street. The road on left appears to be part of Dean Street. Buildings on other side are on lower State Street. They all were replaced by the D&H Building.

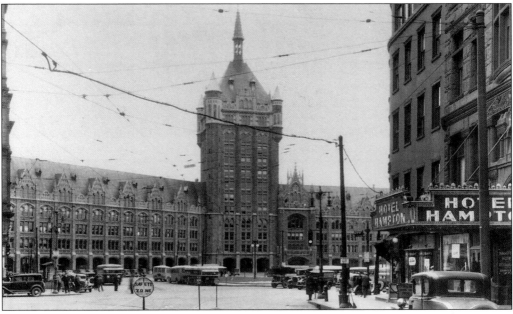

THE D&H BUILDING. Here is the D&H Building, which replaced the structures in the previous few photographs. Constructed in 1915, the building was designed by Albany architect Marcus Reynolds, who based this Flemish Gothic design on the Guild Hall of the Cloth Makers in Ypres, Belgium, commonly called Cloth Hall. The D&H Building is now used by the State University of New York for offices.

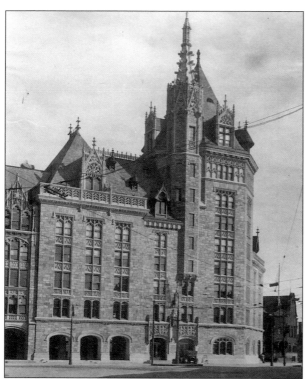

THE ALBANY EVENING JOURNAL OFFICE. Attached to the D&H Building is the Albany Evening Journal office, constructed between 1916 and 1918. The *Evening Journal* was first issued on March 22, 1830, with Thurlow Weed as editor. The newspaper had anti-Masonic origins. The building also included the penthouse apartment of newspaper owner William "Billy" T. Barnes. Barnes led the Republican machine that was later replaced by the O'Connell-Corning political machine.

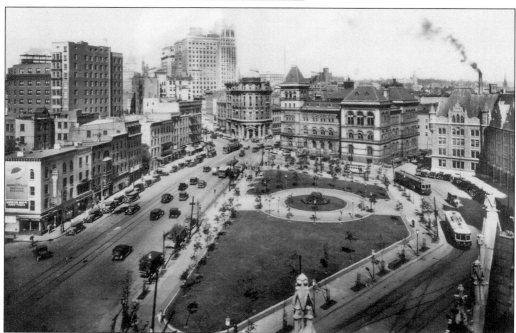

THE D&H PLAZA, c. 1930s. Here is the D&H Plaza, c. 1930s. Notice the trolleys circling the plaza. During the 1960s, buses did the same. The area is now closed off. This plaza site is one of the most important archeological areas of Albany. The buildings on the left are still in use.

THE HUDSON RIVER DAY LINE. The ticket office of the Hudson River Day Line sold tickets to New York City and ports along the way. Passengers paid the fare and then walked up to Steamboat Square. There, the steamers *Hendrick Hudson, Albany,* and *Robert Fulton* left daily at 8:30 a.m. between May 27 and October 25. Each steamer had an orchestra. Today, the ticket office is a restaurant.

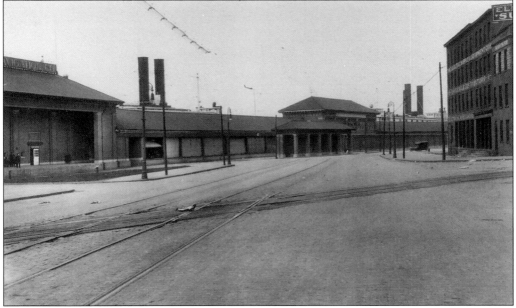

STEAMBOAT SQUARE. Steamboat Square was located at the foot of Madison to Lodge Streets along Broadway. This is where passengers boarded the steamers to New York City. The smokestacks of two steamers waiting for boarding are visible.

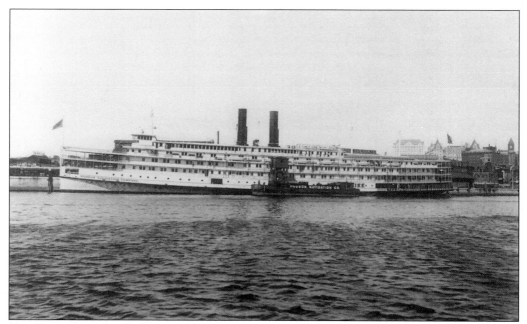

THE *BERKSHIRE*. Docked at Steamboat Square is the *Berkshire*, owned by the Hudson Navigation Company, called the People's Line. This company's steamers left daily at 8:00 p.m. The Day Line ticket office is on the right, and the capitol is in the distance.

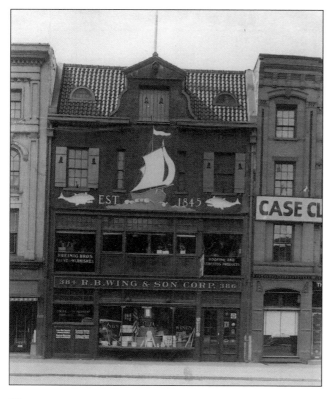

BROADWAY, WEST SIDE, 1948. This photograph taken in 1948 shows 384–386 Broadway, west side. Across from the D&H Plaza is R.B. Wing & Son, who started in 1845 in the same area of the city.

THE ALBANY ARGUS BUILDING.
Here is the Albany Argus
newspaper building at the
southwest corner of Broadway
and Beaver Street. The building
is still in use. The *Argus* was first
published on Tuesday, January 26,
1813. Originally a semi-weekly, it
went daily on August 18, 1825. At
the time, it was Albany's oldest
newspaper. Jesse Buel was editor
and publisher.

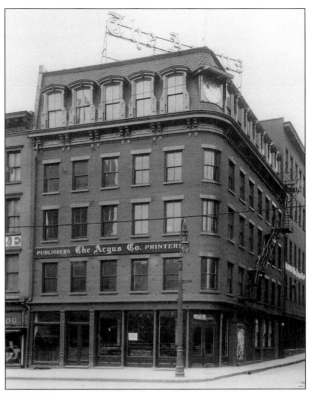

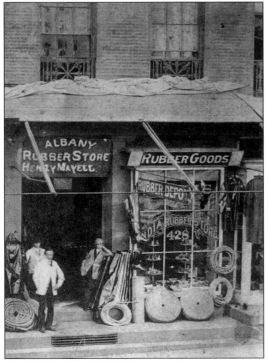

THE ALBANY RUBBER STORE. The
Albany Rubber Store was located on 428
Broadway near State Street. Henry Mayell
was the owner. The store was replaced by
the Douw Building.

THE DOUW BUILDING. The Douw Building was located on the southwest corner of Broadway and State Street. Erected in 1842, it was one of Albany's oldest standing buildings until it was razed in 1969, for no apparent reason.

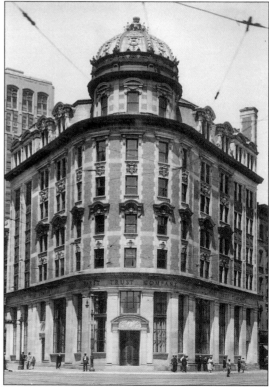

THE FIRST TRUST COMPANY. The First Trust Company was located on the northwest corner of State Street and Broadway. It opened for business on May 1, 1900. Beginning in 1904, the Albany Museum building was replaced in stages. Albany architect Marcus Reynolds designed the front corner section. First Trust is still in business.

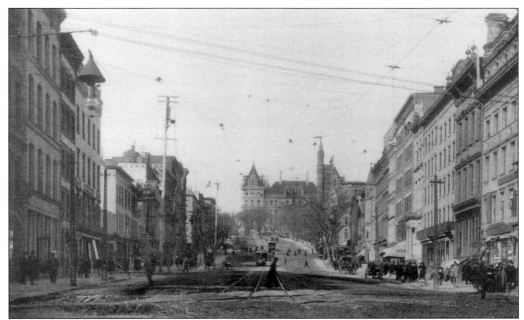

UP STATE STREET, 1897. This view was taken in 1897, looking west up State Street. The capitol is visible in the distance. The buildings on the right and on the left have either been replaced or are gone.

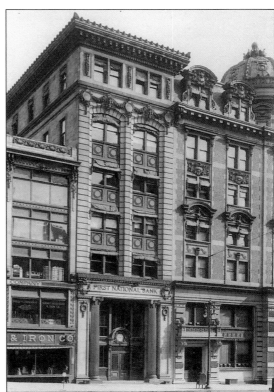

THE FIRST NATIONAL BANK. The First National Bank at 35–37 State Street, north side, was built in 1908. The bank was first organized on January 26, 1864. It was the first bank to come under the national banking system.

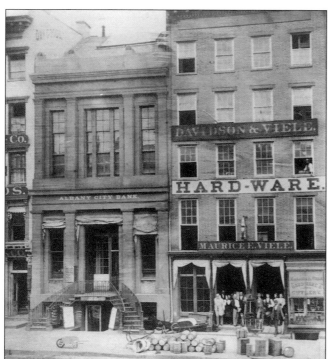

THE ALBANY CITY BANK, c. 1860. This photograph shows the Albany City Bank at 47 State Street, north side. The bank was organized on April 30, 1834, with Erastus Corning as president. This building was purchased in 1840 from Joel Rathbone and was converted into the bank. The bank reorganized in 1864 as a national bank, with the son of Erastus Corning as president. A new bank building was erected on the site in 1874. Next to it at 43 State Street is Albany Hardware, which was established in 1790 by Samuel Hill in the old house of L. Pruyn.

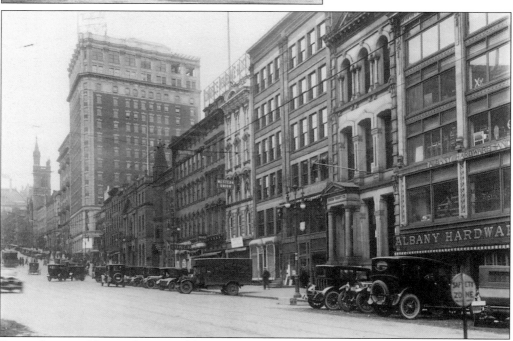

STATE STREET, NORTH SIDE. Visible in this view of the north side of State Street are Albany Hardware, the Union Trust Company, Western Union, Mechanics & Farmers Bank—at the corner of James Street—and State Bank. The only building that still exists is Farmers Bank. The tall building is the Ten Eyck Hotel, on the corner of North Pearl Street.

THE NEW YORK STATE NATIONAL BANK. The New York State National Bank was incorporated in 1803. The bank's first president was former governor James Tayler. The building at 69 State Street was designed by Philip Hooker, with later design work done by Marcus Reynolds. The facade was removed and attached to a larger building now on the corner of North Pearl Street.

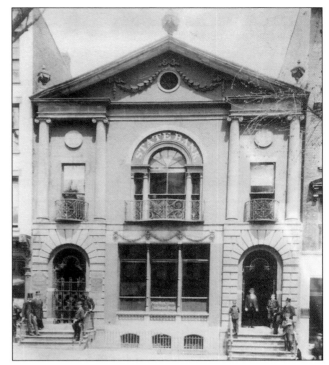

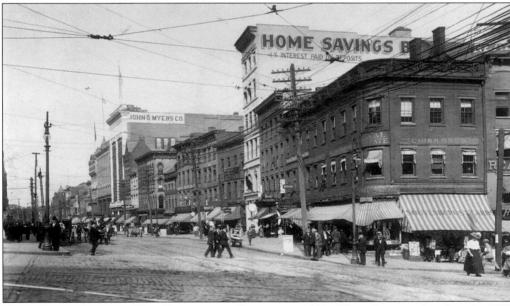

HOPE BANK CORNER, THE DEARSTYNE BUILDING, 1912. This photograph taken in 1912 shows the Dearstyne Building, at the northeast corner of State and North Pearl Streets. The Lydius House, one of the oldest Albany homes, occupied this corner until 1833. The Home Savings Bank, which was incorporated on May 10, 1871, and spent its first 25 years in the old Commercial Bank building on State Street, moved into this building at 13 North Pearl Street in 1897. Its modern ladies' room was very popular with Albany women.

CORNER OF STATE AND NORTH PEARL. This photograph was taken in 1940, looking north at the northeast corner of State and North Pearl Streets. Notice that the State Bank facade has been incorporated into what is now Fleet Bank and takes up the whole block down to James Street. Home Savings, next to Fleet, was originally known as the 6th Ward Savings Bank. It changed its name in 1872, moved here from the Commercial Bank building at 40 State Street in 1897.

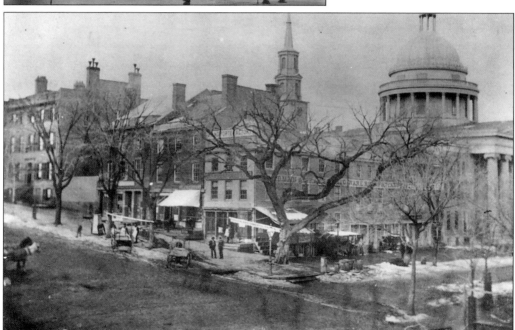

ELM TREE OR WEBSTER'S CORNER. The northwest corner of State and North Pearl Streets is known as Elm Tree Corner or Webster's Corner. This was originally the home of Philip Livingston, a signer of the Declaration of Independence. The elm tree, planted by Livingston, was 123 years old when it was chopped down on June 15, 1877. The block includes a pianoforte manufacturer and the Second Baptist Church, which was used until 1870.

ELM TREE CORNER. This *c.* 1880 photograph of the northwest corner of State and North Pearl Streets shows Tweddle Hall, the concert hall that replaced the pianoforte company in 1860. Tweddle Hall burned in 1883 and was subsequently rebuilt. The old frame building that was first on this corner was known as Webster & Skinners' Bookstore. For 50 years the *Gazette and Daily Advertiser* was published there. The building was demolished on April 22, 1859.

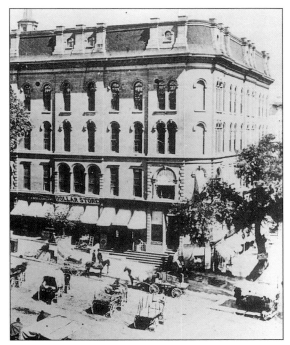

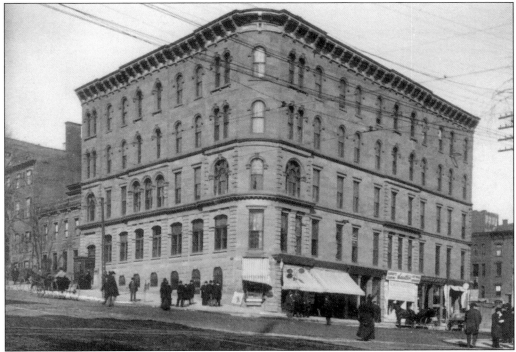

TWEDDLE HALL. This 1897 photograph shows the rebuilt Tweddle Hall, on the northwest corner of State and North Pearl Streets. The concert hall was erected by attorney John Tweddle, who used mason Robert Aspinall and carpenter John Kennedy as builders. The hall was razed to make way for the new Ten Eyck Hotel.

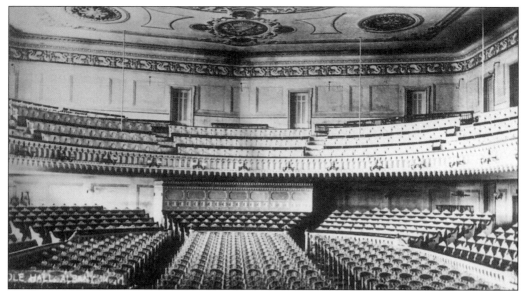

The Interior of Tweddle Hall. Concerts, sermons, lectures, and fund-raisers were held here. The hall was 110 feet deep and 75 feet wide.

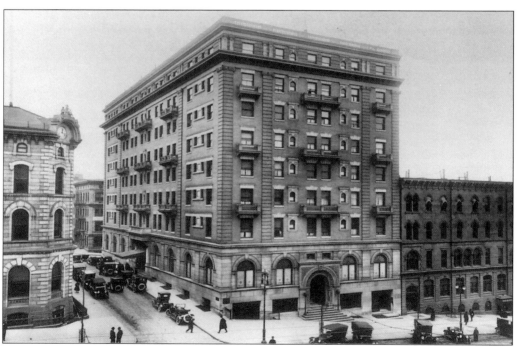

The Ten Eyck Hotel. The Ten Eyck Hotel, on the north side of State Street at the corner of Chapel Street, was built in 1899 by F.W. Rockwell. In 1915, the hotel expanded by building a 15-story "skyscraper" on the site of Tweddle Hall, shown here on the right.

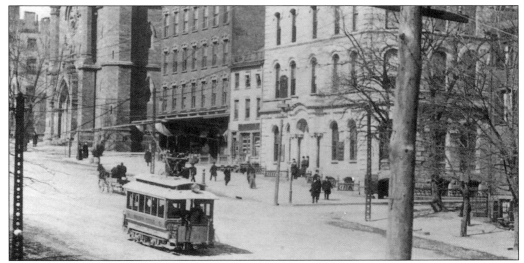

ST. PETER'S CHURCH. This view shows the Electric Pine Hills trolley going up State Street at the corner of Chapel Street, with the Albany Savings Bank on the right. The original St. Peter's Church was built in 1803. The church pictured here is the third building, designed by Richard Henry Upjohn and built in 1859. Lord George Augustus Howe, who died attacking Fort Ticonderoga on July 6, 1758, during the French and Indian War, is buried inside this church. When they exhumed him from a previous site for burial at the church, they opened the coffin and found that his hair had grown several inches.

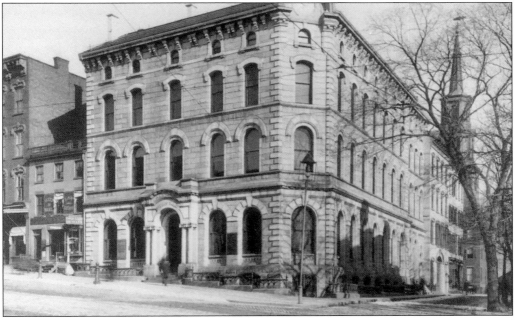

THE ALBANY SAVINGS BANK, 1897. The Albany Savings Bank, on the corner of State and Chapel Streets, was incorporated on March 24, 1820. Stephen Van Rensselaer was the bank's first president. Designed by architects Fuller & Woolcott, this building was erected in 1874–75. On the first day of operations, 21 depositors left a total of $527. Albany Savings was the second incorporated savings bank in New York State. It is now Albank.

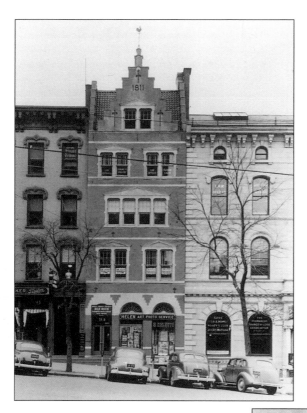

ALBANY INSURANCE. Next door to Albany Savings Bank, at 93 State Street, was Albany Insurance. Founded in 1811, the company insured many of Albany's buildings up to the late 19th century. The company records, if ever located, could provide historical researchers with a wealth of information.

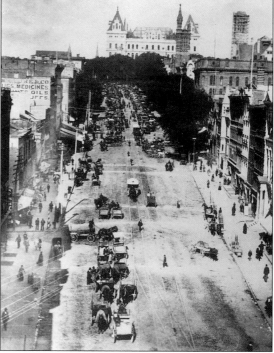

TOWARD CAPITOL HILL, 1881. This view was taken in 1881, looking up State Street toward Capitol Hill. The roof of the capitol was just being completed. The new city hall, shown here with scaffolding on the tower, was being built. Lots of wagons were on upper State Street for the public market, with a horse-drawn trolley in their midst. The State Street horse trolley began operating on February 22, 1864.

THE NATIONAL COMMERCIAL BANK. The National Commercial Bank was located at 38–40 State Street, where the Hampton Hotel now stands. Incorporated in April 1825, the bank was chartered as a national bank on May 31, 1865. It became the National Commercial Bank in 1888. The Albany Board of Trade was organized on May 24, 1847, and moved its offices here on March 3, 1873. In these offices, on March 14, 1866, the powerful national iron moulders union elected Charles Eddy of Troy as its president. The Albany Chamber of Commerce also was located here.

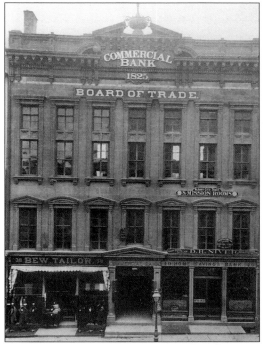

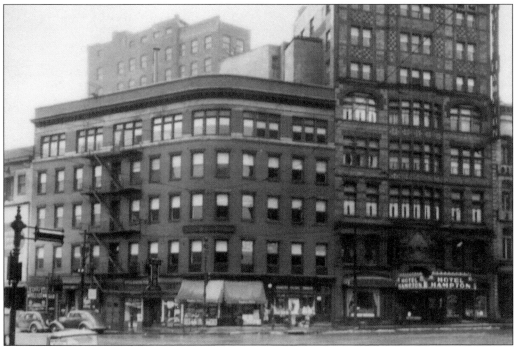

THE HAMPTON HOTEL. The Hampton Hotel, on the right, was built in 1906 at 1 State Street. According to historian John Wolcott, the hotel is unusual because its structure contains much of the previous Commercial Bank and earlier Adelphi Hotel buildings. On the left is the Douw Building.

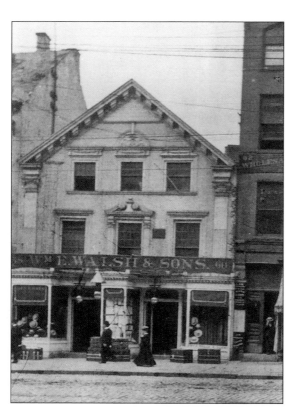

JOEL MUNSELL'S PRINTING OFFICE.
Joel Munsell published numerous
Albany history items at his printing
office. Much of Albany's early history
is known thanks to him. Munsell died
on January 15, 1880. From 1795 to 1830,
the building was known as Gable Hall.
It was the home of Gov. John Jay. It was
torn down in 1902 to make room for the
National Commercial Bank and Trust.

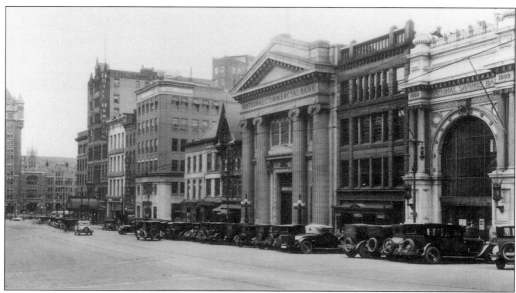

STATE STREET, SOUTH SIDE. This view of the south side of State Street shows the National
Commercial Bank in the middle, Keeler's Restaurant—famous for its oysters—to the left of it,
and the National Savings Bank on the right. Several of the pictured buildings are gone.

JACK'S RESTAURANT. Jack's Restaurant was established in 1913. It is one of the last eating traditions in Albany that is still serving. The building, located next to the Hampton Hotel, was erected in 1875 on the south side of State Street.

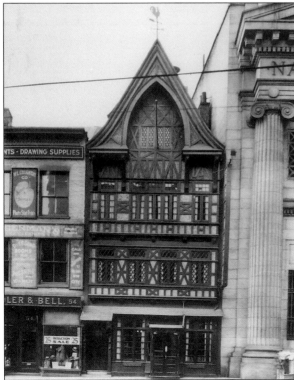

KEELER'S RESTAURANT. For years Keeler's Restaurant, at 56 State Street, south side, was a popular eatery. There was also a Keeler's Hotel on Broadway.

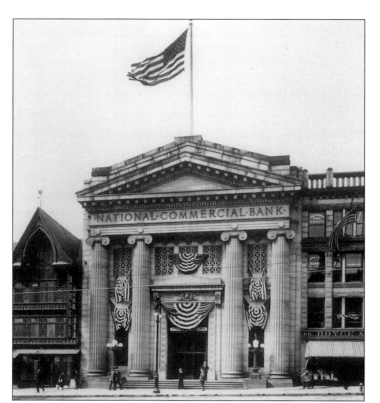

THE NATIONAL COMMERCIAL BANK. The National Commercial Bank moved to 64 State Street, south side, in 1902. The bank was incorporated in April 1825 and was chartered as a national bank on May 31, 1865.

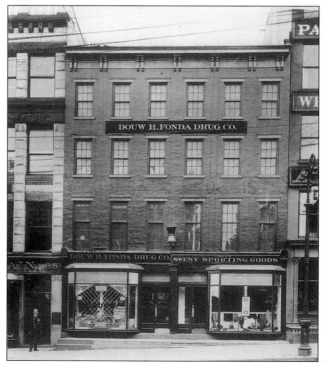

DOUW FONDA'S DRUG COMPANY, 1890. Douw Fonda's Drug Company, 70 State Street, was founded in 1809. D.H. Fonda, W.B. French, and H.R. Wright joined together in 1879 and incorporated in 1889. The business was one of the oldest in the city.

THE NATIONAL SAVINGS BANK. Fonda's drugstore was torn down in 1902 to make room for the National Savings Bank building at 70 State Street, south side. The bank was incorporated in 1868, with Erastus Corning as president.

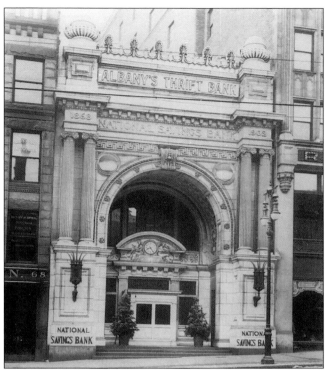

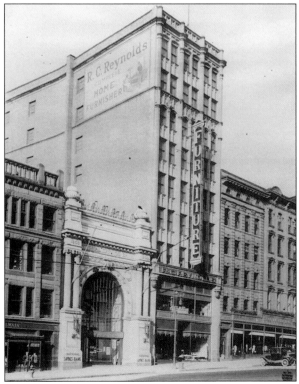

R.C. REYNOLDS, 1947. In Albany, the R.C. Reynolds furniture store was located on the south side of State Street, as shown in this 1947 photograph. In Troy, Reynolds had a store in the old McCarthy Building on River Street.

STEEFEL BROTHERS. The Steefel Brothers clothing store was located at 78–82 State Street, south side. The store carried clothes for men and boys.

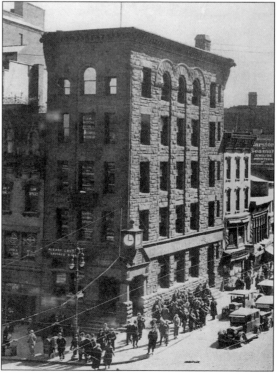

THE ALBANY COUNTY SAVINGS BANK, 1924. The 1667 Staats House, one of Albany's oldest Dutch buildings, was torn down to make room for the Albany County Savings Bank, built during the city's bicentennial in 1886 on the southeast corner of South Pearl and State Streets.

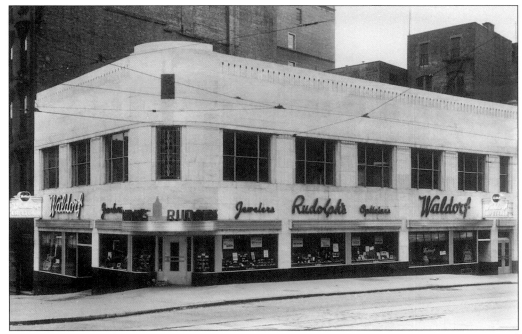

THE WALDORF. The Albany County Savings Bank, on the southeast corner of South Pearl and State Streets, was replaced by this art deco building. Prices at this Waldorf were very reasonable, similar to the old White Tower.

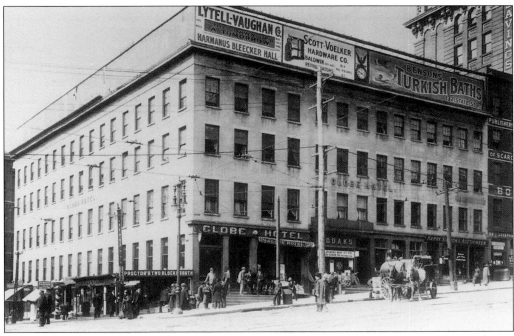

THE GLOBE HOTEL, c. 1902. This c. 1902 photograph shows the Globe Hotel on the southwest corner of South Pearl and State Streets. Here, Harry Simmons had his auction house, with an entrance to it on the Howard Street side as well.

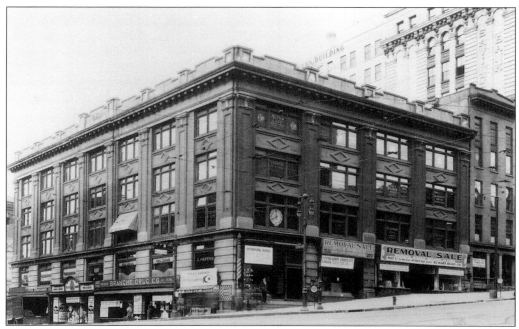

THE ROSE-KIERNAN BUILDING. Renovations changed the Globe Hotel into the Rose-Kiernan Commercial Building. Commonly called the Arkay (R-K) Building, it was located on the southwest corner of South Pearl and State Streets.

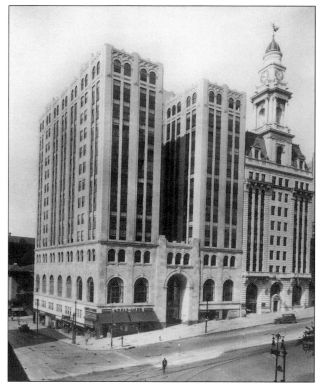

THE NATIONAL SAVINGS BANK. The National Savings Bank replaced the Arkay Building. The bank was incorporated in 1868, with Erastus Corning as president. Its earlier building was at 59 State Street.

STATE STREET BUILDING, c. 1900. This photograph was taken *c.* 1900 of 98–100 State Street, south side. The building on the right was replaced by the City and County Savings Bank in 1902.

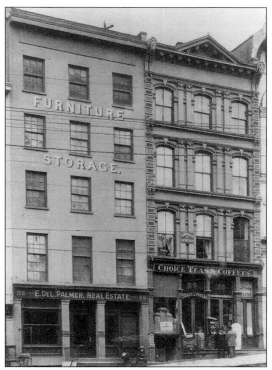

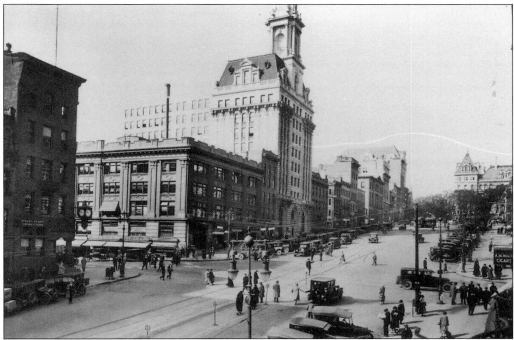

UP STATE, c. 1925. This view was taken *c.* 1925, looking up the south side of State Street. It shows the Albany County Savings Bank, the Arkay Building, and the combined Albany City and County Savings Bank.

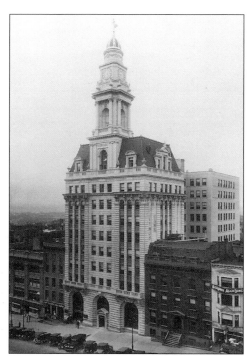

THE ALBANY CITY AND COUNTY SAVINGS BANK, 1947. The first section of the Albany City and County Savings Bank, pictured here on the left, was erected in 1902. The middle and right portions were built to match the original building in 1925. The Eldredge House, the home of Erastus Corning, is on the right. The house later became Joe's Restaurant.

THE CORNER OF STATE AND LODGE. This art deco-style building on the southeast corner of State and Lodge Streets was Albany's attempt to build a skyscraper. Erected in 1928, the Standard Commercial Building serves today as the offices of Albany County. On September 11, 1815, the Boys Academy held its first session in a dwelling on this site.

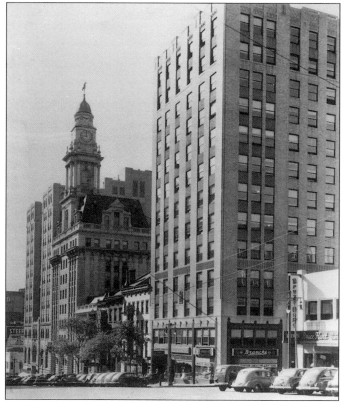

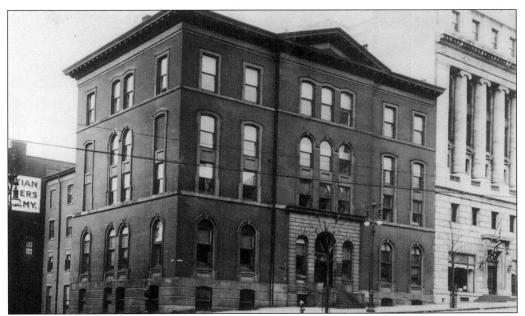

GEOLOGICAL HALL. The original State Hall was built on the southwest corner of State and Lodge Streets and became a museum for the State Geological Corps, now the New York State Geological Survey. Geological Hall was erected in 1855. It contained rooms for exhibits of geology and agriculture, and became the State Museum of Natural History. On December 8, 1866, it received bones from the mastodon found in Cohoes during excavations for a mill. On December 23, 1867, the mastodon exhibit opened here and attracted a large number of visitors.

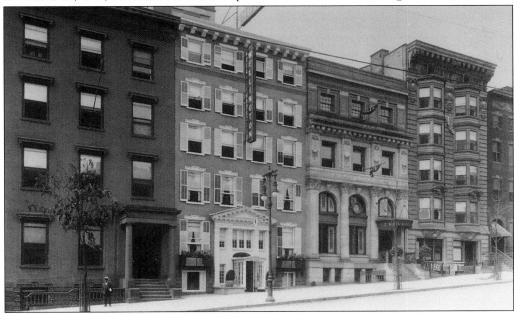

THE WELLINGTON HOTEL, 1917. This 1917 photograph shows the Wellington Hotel, located on the south side of State Street between Lodge and Eagle Streets. The buildings pictured here are now vacant and likely will be demolished, in keeping with Albany tradition.

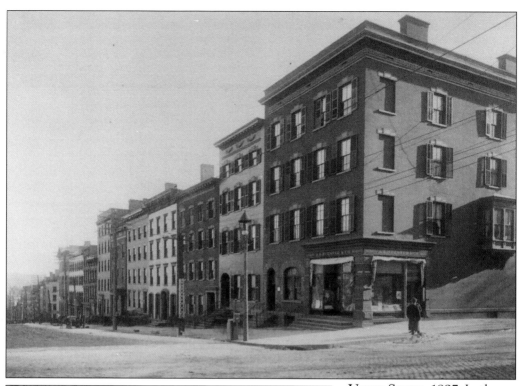

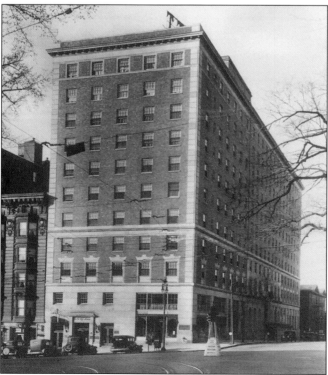

UPPER STATE, 1897. In the late 19th century, Upper State Street was an area of elegant homes. The building on the corner of Eagle Street was the executive mansion of two governors: Edwin D. Morgan and Reuben E. Fenton. Later, the homes were turned into businesses. Geological Hall is visible toward the bottom.

THE DEWITT CLINTON HOTEL. The DeWitt Clinton, on the southeast corner of State and Eagle Streets, was the hotel where New York State legislators made their deals. Today, the hotel is an apartment house.

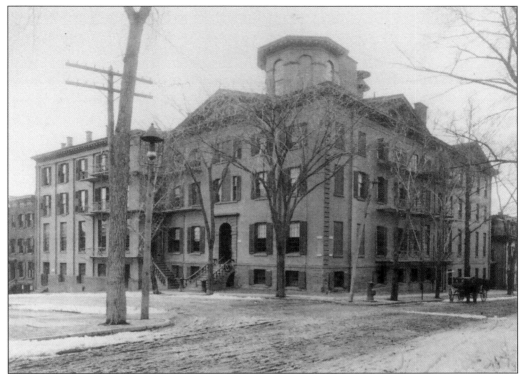

THE ALBANY HOSPITAL, 1897. Directly behind the DeWitt Clinton was the Albany Hospital, on the southeast corner of Howard and Eagle Streets. The Albany Hospital, which began in 1848 on the corner of Dove and Lydius (Madison) Streets, opened here on August 8, 1854. This structure was built in 1834 as the Albany Jail and was refitted as a hospital after a new jail was built on Maiden Lane.

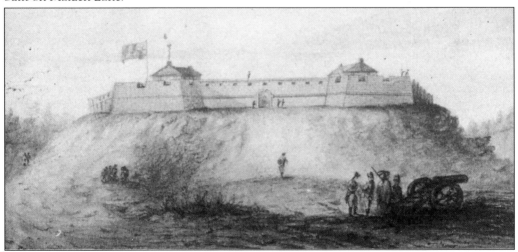

FORT FREDERICK. Perched atop Capitol Hill near the present St. Peter's Church, Fort Frederick had its guns aimed at the river below and at the Pine Bush area on the west. This is an original painting of the fort, which was built in 1676 and demolished in 1784. Notice parts of the abandoned stockade fence on both sides.

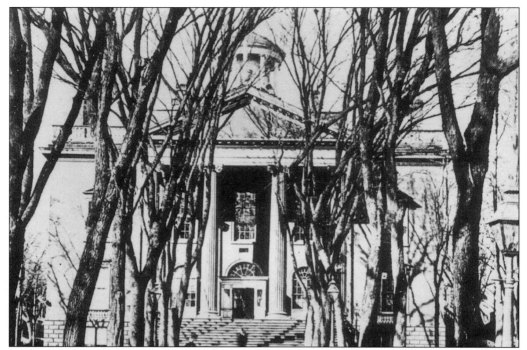

THE OLD CAPITOL. Albany became the capital city in 1797. The cornerstone for the original capitol building was laid on April 23, 1806, just below the site of the existing capitol. The old building had a time ball on the top that dropped regularly at noon. Controlled by the Dudley Observatory by wire, it was one of only two time balls dropped by electromagnetism in the world; the other was in Greenwich, England. The old capitol was replaced by the new one in 1883.

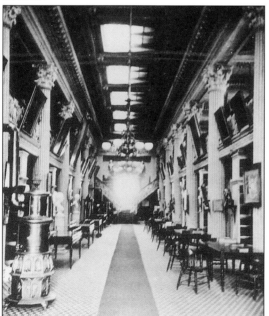

THE NEW YORK STATE LIBRARY, 1884. The first New York State Library was situated in a fireproof structure behind the old capitol. The library was established in 1818 at a cost of $3,000. John Cook was appointed librarian and had an annual budget of $500 to purchase books.

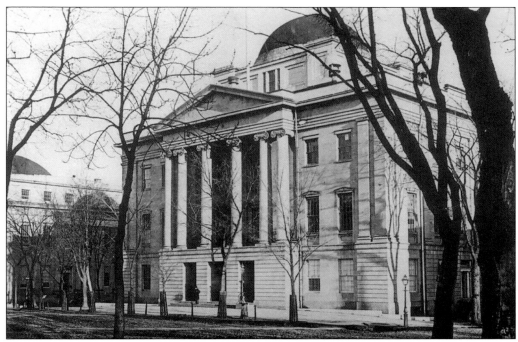

EARLY CITY HALL. This Albany City Hall was built in 1831–32 on Eagle Street between Maiden Lane and Pine Street. It burned on February 10, 1880.

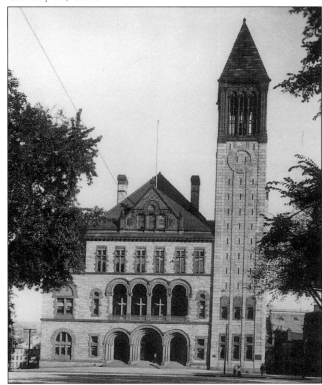

PRESENT CITY HALL. The new Albany City Hall, designed by Boston architect H.H. Richardson, was built in 1881–83. It is still in use.

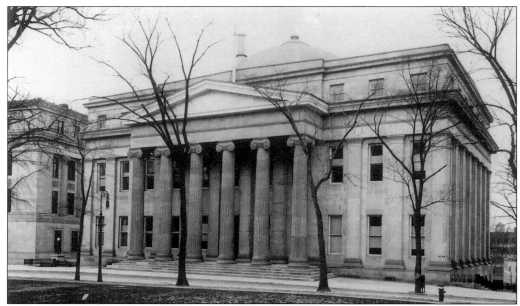

STATE HALL. This new State Hall replaced the old one located on Lodge and State Streets. It was designed in the Greek Revival style by architect Henry Rector and was built in 1842 on Eagle Street between Pine and Steuben Streets, next to Albany City Hall. It housed the offices of the chancellor, supreme court judges, secretary of state, and others. It currently serves as the court of appeals building.

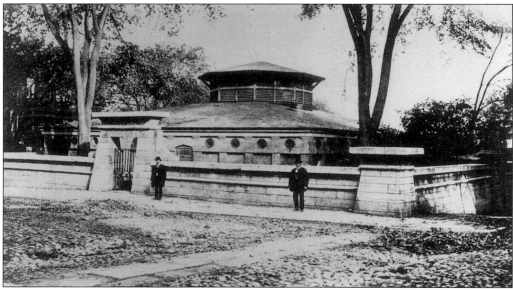

THE WATER RESERVOIR, 1861. This 1861 photograph shows the water reservoir on Eagle Street between Steuben and Columbia Streets. The structure is one of the few examples of Egyptian Revival architecture. Albany originally got its water from wells, then from the Pine Bush, and from harnessed streams and springs, including the Hudson in 1897. This reservoir may have been holding water from the Maezlandt Kill, in Menands. The British army hospital was located here during the French and Indian War and trained local women to be nurses.

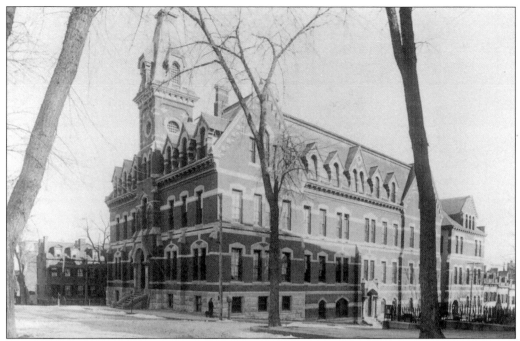

THE OLD HIGH SCHOOL. The reservoir on Eagle Street was replaced by the Albany High School, which opened on May 4, 1876. Public schools began in 1830 in Albany and by 1880, a total of 26 school buildings had been erected.

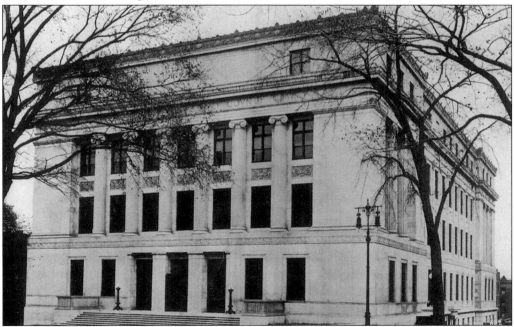

THE ALBANY COUNTY COURTHOUSE. The Albany County Courthouse, located on Eagle Street between Steuben and Columbia Streets. replaced Albany High School in 1916. The courthouse is currently in use.

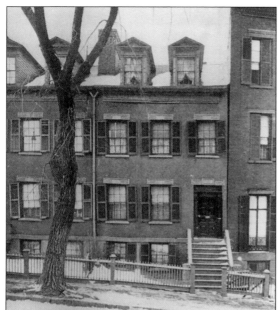

THE HOME OF JOSEPH HENRY. Joseph Henry (1797–1878), one of the most respected scientists in the country, lived in this house at 105 Columbia Street, north side, directly across from the courthouse. Henry invented the electric motor, was the father of daily weather forecasts, served as the first head of the Smithsonian (1846), and founded the American Association for the Advancement of Science—the largest scientific organization in the world today. When Henry died on May 16, 1878, the entire federal government closed so that the president, vice president, and members of the Cabinet, Supreme Court, and Congress could attend his funeral. In 1883, the government closed again to dedicate a statue in his honor.

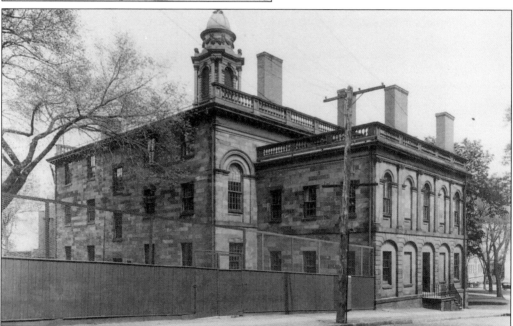

ALBANY ACADEMY, c. 1910. Albany Academy, one of the oldest boys schools in existence, began in 1790. This c. 1910 photograph shows the Lafayette and Park Street entrance, now Lafayette (Academy) Park. The academy building constructed in 1815 now houses the board of education. Albany Academy today is located on Academy Road. Joseph Henry, the prominent scientist, taught at the academy and in 1832, discovered a way to transmit sound over wire by magnetic force—the telegraph. One of Henry's friends was inventor Samuel F.B. Morse. Albany was the first city to be connected by wire with other cities. By 1845, Buffalo, Albany, and Springfield were connected by telegraph.

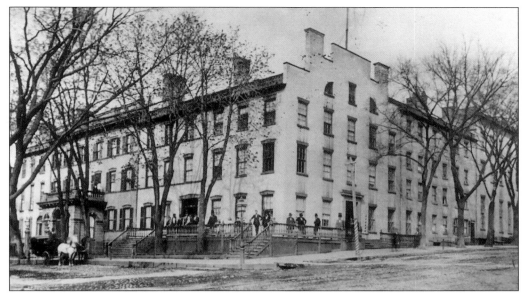

CONGRESS HALL. Congress Hall was built in 1815 on the southwest corner of Washington Avenue and Park Street, north of the old capitol building. Lafayette entertained here in 1824. Albert Edward, Prince of Wales, was entertained here in 1860. President Abraham Lincoln, newly elected, was honored at a reception here in 1861. Congress Hall closed its doors on June 1, 1865. It was demolished in 1878 to make room for the new capitol building. Adam Blake, who owned Congress Hall, built the Kenmore Hotel right after the demolition.

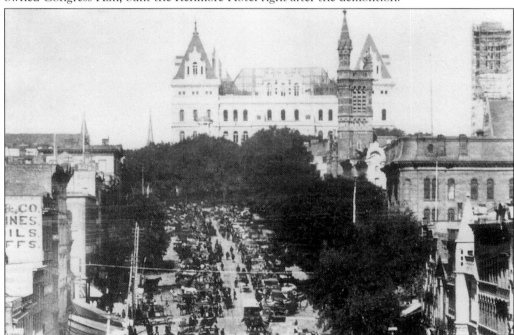

UNDER CONSTRUCTION. This view shows the new capitol as it was being built. Construction began in 1867 and the building opened in 1879, even though it was not completed until c. 1881–83.

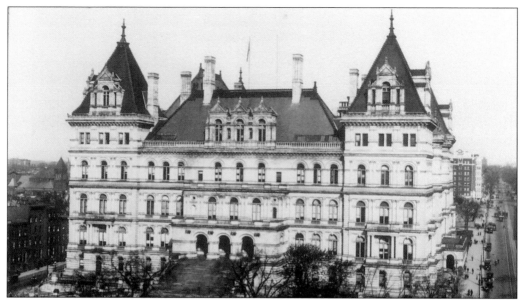

THE CAPITOL BUILDING, 1946. This photograph of the capitol building dates from 1946. Albany became the capital city in 1797, and the capitol building became the seat of New York State government. This capitol is recognized as having one of the most beautiful interiors of any building in the country. The Fort Frederick apartment building is visible up Washington Avenue.

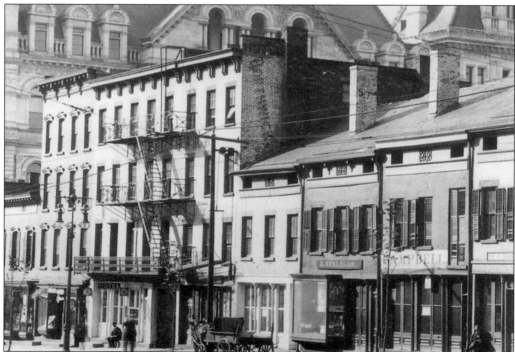

HOTEL BOTHWICK. The Hotel Bothwick was located at 74 Washington Avenue, on the south side west of the capitol. All of the buildings pictured here were torn down for Capitol Park.

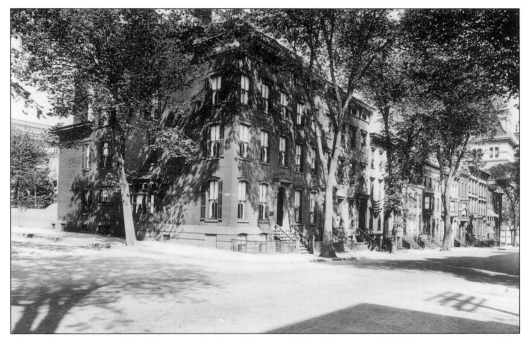

STATE AND SWAN. This photograph shows homes along the west side of State Street and the northeast side of Swan Street. These houses were also torn down to make way for Capitol Park.

THE NORTHEAST CORNER OF CONGRESS AND SWAN. Today, Congress Street and this portion of Swan Street no longer exist. The area is now the westernmost part of Capitol Park. The State Education Building is on the left..

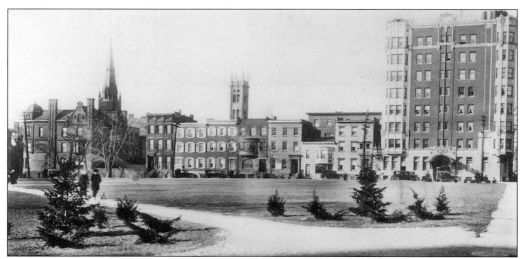

CAPITOL PARK. Notice all of the buildings on the west side of Swan Street. They soon made way for the state government. The Fort Frederick apartment building was put on rollers and moved to where it exists now, with the front entrance now in the alley; the rest of the buildings were destroyed.

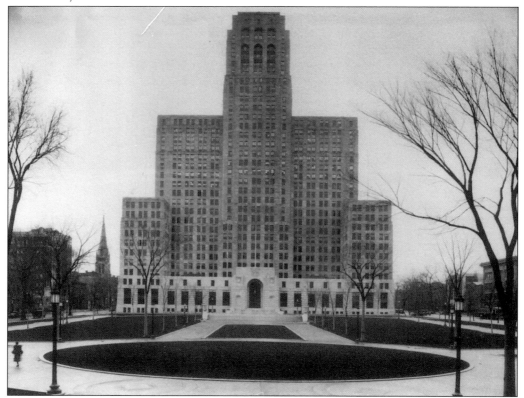

THE ALFRED E. SMITH STATE OFFICE BUILDING. The Alfred E. Smith State Office Building was erected in 1929 on Swan Street between Washington Avenue and State Street. It was built as a monument to New York's prosperity—at the expense of Albany's history.

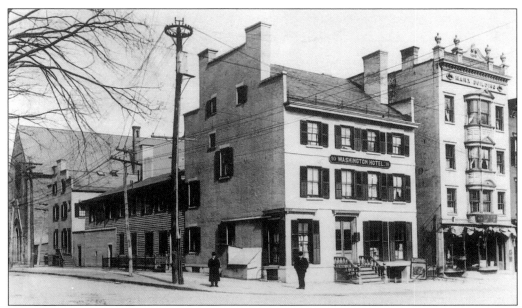

THE WASHINGTON HOTEL. The Washington Hotel was located at 91–93 Washington Avenue on the northeast corner of Swan Street, and the Marx Building was at 89 Washington Avenue. Both were demolished to make room for the State Education Building.

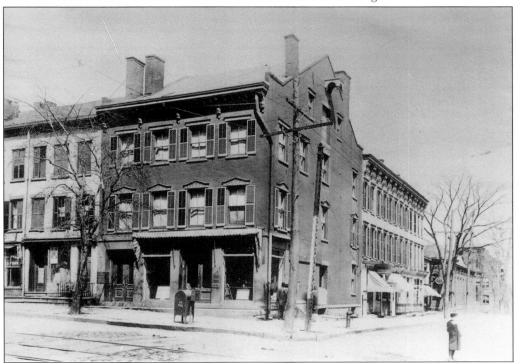

THE CORNER OF WASHINGTON AND NORTH HAWK, 1900. This 1900 photograph shows 33 Washington Avenue at the northwest corner of North Hawk Street. The structure was torn down to make room for the State Education Building.

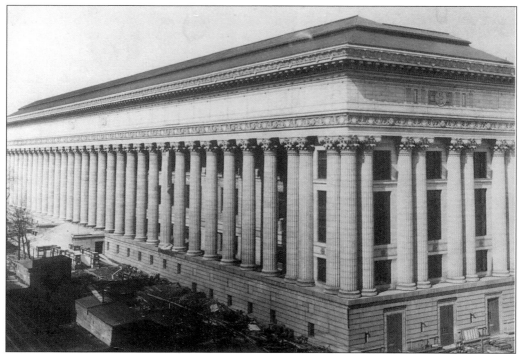

THE NEW YORK STATE EDUCATION BUILDING, 1912. An entire block from 33 to 91 State Street (see previous photographs) was demolished for the erection of the New York State Education Building in 1912. The New York State Museum, one of the finest museums in the United States, was moved from Geological Hall on State Street to the State Education Building's fifth floor. Exhibits from the State House on Eagle Street were also moved here.

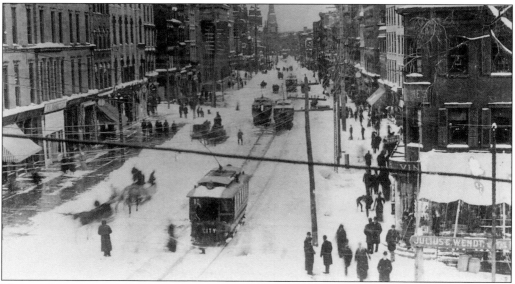

NORTH PEARL AND STATE, 1891. This photograph of North Pearl and State Streets was taken in 1891, looking north. The Albany Street Railway was organized on September 24, 1863, and cars began running on Pearl Street on February 22, 1864.

THE WIDOW STURDEVANT HOME.
The Widow Sturdevant Home, a Dutch house with a step gable roof, was located to the left of the Female Academy on North Pearl Street. A modern front was put on the house, and it became well known as the McCaffrey & Homes Bakery. Writing in 1867, publisher Joel Munsell said a Dutch cookie baker may have lived in the house before Widow Sturdevant moved in c. 1820.

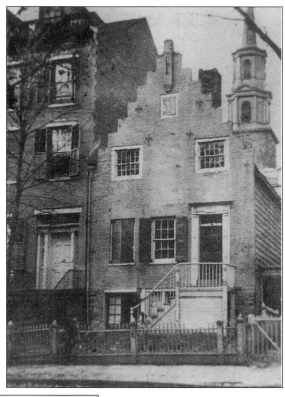

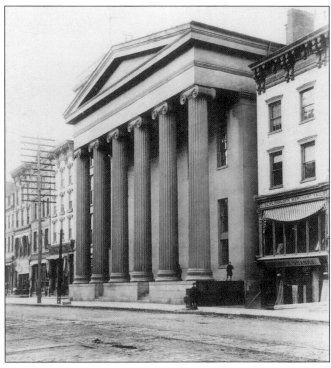

THE FEMALE ACADEMY. The Female Academy was built in 1834 on the west side of North Pearl Street. Dulcodrey Holstein, a staff officer under Napoleon, taught French here. Ebenezer Foot founded the first building on Montgomery Street in 1814 as the Union School. On June 26, 1821, the cornerstone was laid for a building on Montgomery Street. In the 1890s, the academy was moved to a pair of buildings on Washington Avenue near the Albany Public Library. Now called the Albany Academy for Girls, the institution is on Academy Road.

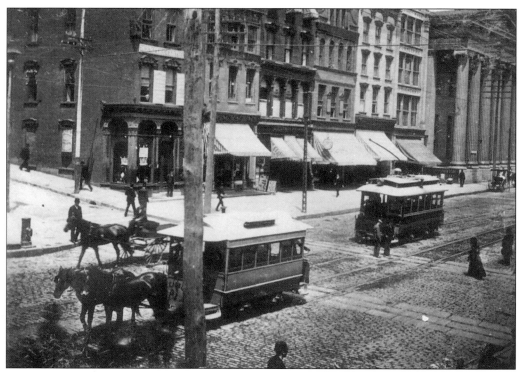

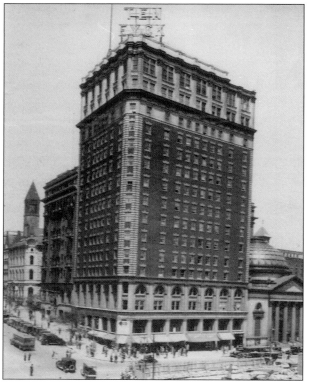

STREETCARS, 1891. This 1891 photograph shows horse-drawn and electric streetcars crossing Maiden Lane on North Pearl Street. The Female Academy is on the right. Streetcars began running on State Street on February 22, 1864. They made their first trip on North Pearl Street to Van Woert Street on September 17, 1866.

THE CORNER OF NORTH PEARL AND STATE. In 1915, the Ten Eyck Hotel was expanded by razing the Tweddle Building and replacing it with this skyscraper at the northwest corner of North Pearl and State Streets. The hotel was torn down in 1971, and the site is now occupied by Albank.

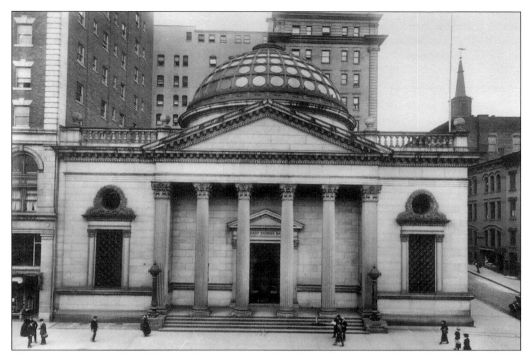

THE ALBANY SAVINGS BANK. The Albany Savings Bank, on the southwest corner of North Pearl Street and Maiden Lane, was razed in the 1970s to make room for the office building that occupies the site today. Many people withdrew their money from the bank when the building was destroyed.

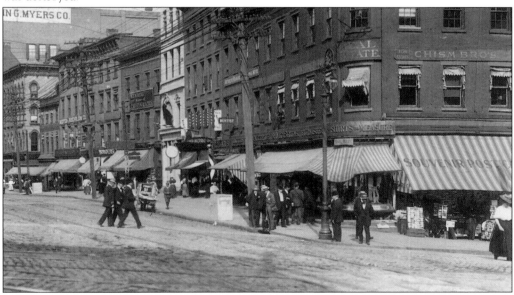

THE DEARSTYNE BUILDING. The Dearstyne Building was located on the northeast corner of State and North Pearl Streets. Almost everyone wore a hat at the beginning of the 20th century. The John J. Myers department store can be seen on the left. Started in 1870, the store was a landmark of Pearl Street for years.

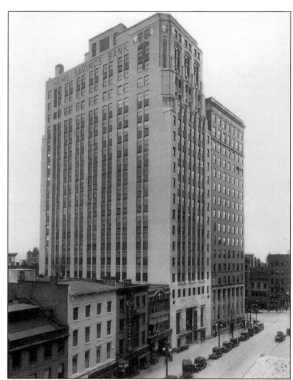

THE STATE BANK. This view of the northeast corner of State and North Pearl Streets was taken looking south. The State Bank, now Fleet Bank, was built in 1927–28 in the Neoclassical design, around the original facade designed by Philip Hooker. The bank faces State Street. North of it is the art deco-style Home Savings Bank, which was built in 1927 to replace its earlier building.

NORTH PEARL STREET. This view shows 32–36 North Pearl Street. The building on the left was erected in 1859. North Pearl Street was a primary shopping area for many years.

THE DRISLANE BUILDING. The Drislane Building was located at 38–42 North Pearl Street, a former site of the Academy for Girls. Customers could buy almost anything here.

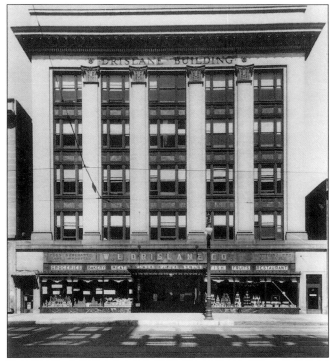

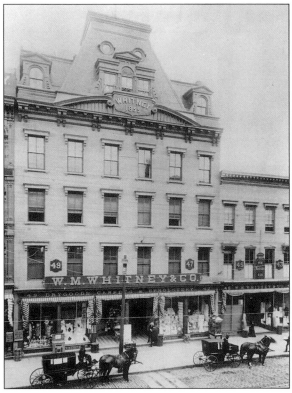

THE W.M. WHITNEY & COMPANY DRY GOODS, 1890. This c. 1890 photograph shows the W.M. Whitney & Company Dry Goods store, located at 43–49 North Pearl Street, between Maiden Lane and Steuben Street, east side. The area is now an extension of Pine Street.

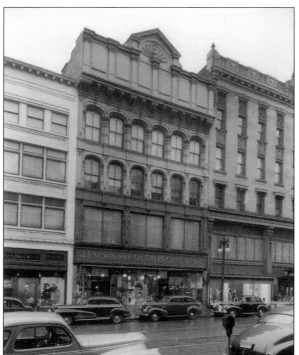

CAST-IRON FAÇADE, 1940. At 51 North Pearl Street is one of only two cast-iron facade buildings in Albany. The Italianate-style building was erected in 1861 by Daniel Bogardus of New York City, considered to be the father of cast-iron architecture. The building was scheduled for demolition after the bank foreclosed on it. However, the author of this book went to bank president Erastus Corning, who was also the mayor of Albany, and convinced him that the building should be saved—and so it was. Today, a street goes past the right side of the building, where Whitney and Myer's stores once stood. The building on the left still stands.

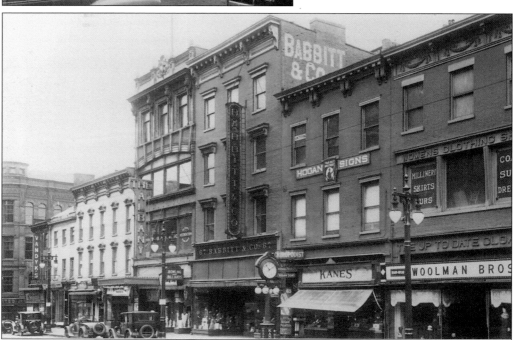

THE ALBANY THEATER, 1925. This photograph of 63–73 North Pearl Street, east side, was taken in 1925, looking northeast. The Albany Theater is the second tallest building on the left. The theater is one of only two cast-iron façade buildings in Albany. The structures to the left of the theater are still standing; those to the right are gone.

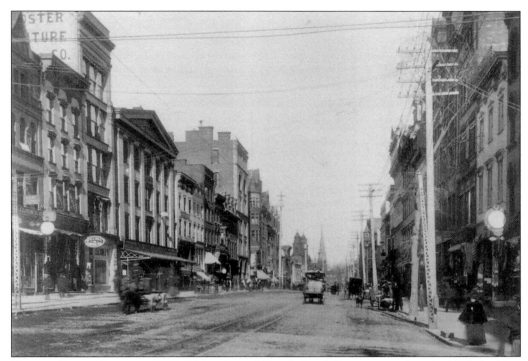

NORTH PEARL STREET, 1897. This view of North Pearl Street was taken in 1897, looking north. Notice that the front of the Girls Academy has been altered. The D&H office building and the YMCA are visible a few doors down from the academy building.

THE D&H OFFICE BUILDING, 1897. This 1897 photograph shows the D&H office building on the left and the YMCA building, built in 1886–87, on the right. Both buildings are still standing. In the middle is Steuben Street, which is now a pedestrian way. The Delaware & Hudson Canal Company incorporated in 1823 to build a canal east from the coalfields to the Hudson River. The canal was completed in 1828. It had the first steam locomotive in North America, the Stourbridge Lion, which made its first run in 1829. At the time, there were only 21 miles of track in the whole country.

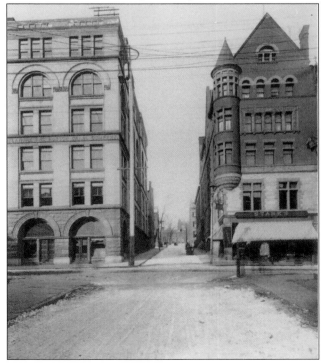

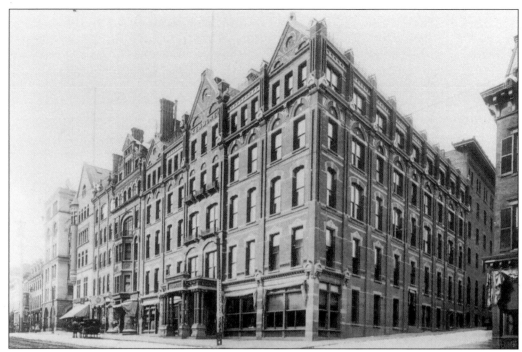

THE KENMORE HOTEL, 1897. Adam Blake, who owned Congress Hall, built the Kenmore Hotel on the southwest corner of North Pearl and Columbia Streets in 1878. The hotel was renovated in 1891. In the 1920s, notorious gangster Legs Diamond frequented the Rainbow Room. He was killed in a house in Albany. The five buildings in the block extending to Steuben Street still stand.

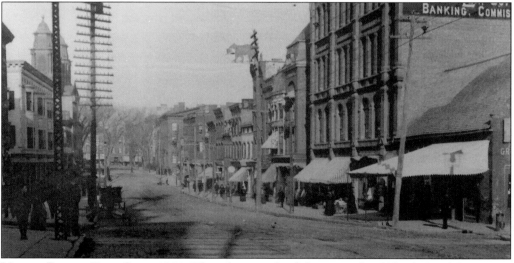

NORTH PEARL, EAST SIDE, 1891. This photograph of the east side of North Pearl Street was taken in 1891, looking north from Columbia Street. John Pemberton's grocery store, formerly the Lansing House, is on the right. The Dutch Reformed Church steeples are visible on the left toward Clinton Square. The large building on the right was built in 1887 and became the Albany Business College.

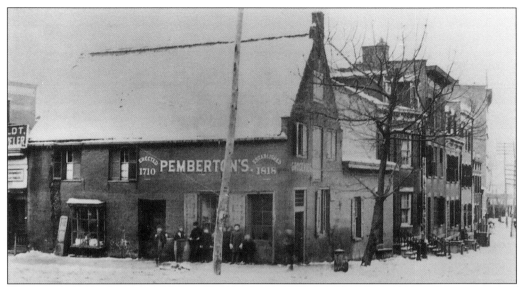

THE PEMBERTON-LANSING HOUSE. The Pemberton-Lansing House, on the northeast corner of North Pearl and Columbia Streets, is said to have been built in 1710 by Col. Jacob Lansing, an American officer in the Revolutionary War. The house stood just outside the stockade north on a line with Pearl Street and was used as lodging by Native Americans who came to trade. Pemberton's store was started in it in 1818. It is said that no two rooms were on the same level, so patrons had to ascend or descend into each room. The building was torn down during the city's bicentennial celebration of 1886.

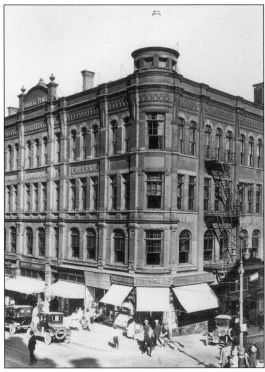

COLLEGE PLACE, c. 1920. This c. 1920 view shows the corner of North Pearl and Columbia Streets. After the Pemberton-Lansing House was torn down, the Albany Business College occupied the site from 1893 to 1933. H.B. Bryant and H.D. Stratton established the college in 1857. E.G. Folsom became a partner in 1862 and purchased the entire school in 1867, calling it Folsom's Business College. Bryant & Stratton is still in business.

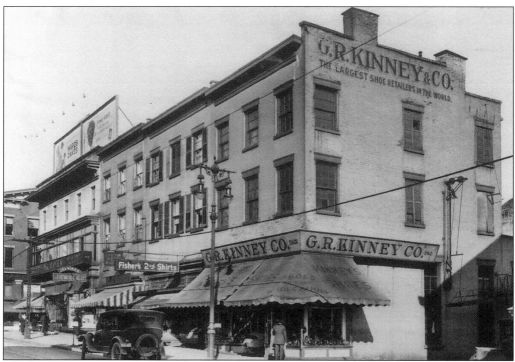

G.R. KINNEY & COMPANY, c. 1922. This c. 1920 view shows G.R. Kinney & Company, located on the northeast corner of Van Tromp and North Pearl Street. The company was billed as the largest show retailers in the world. Van Tromp Street was named after a famous Dutch admiral of the 17th century.

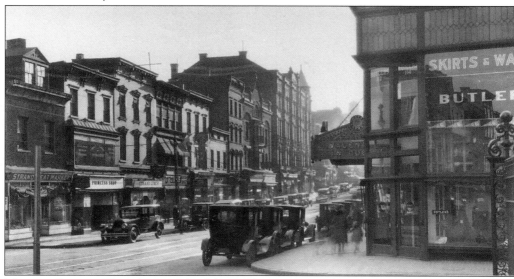

MONROE STREET. This photograph of the southwest corner of Monroe Street was taken looking south on North Pearl Street. This was part of the tannery district. The Albany Business College is visible in the center. All the buildings to the left of the college are now gone. Monroe was originally called Van Schaick Street.

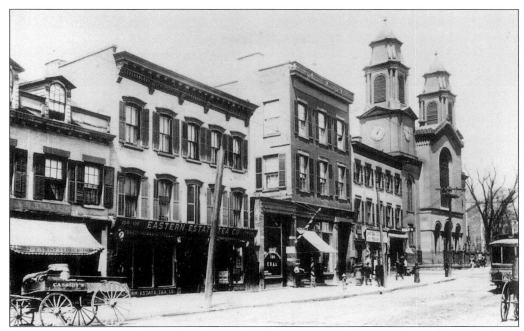

NORTH PEARL STREET, WEST SIDE, c. 1890. This c. 1890 view shows Monroe Street, with the Dutch Reformed Church to the right. The church is still standing, but the rest of the area is now a parking lot.

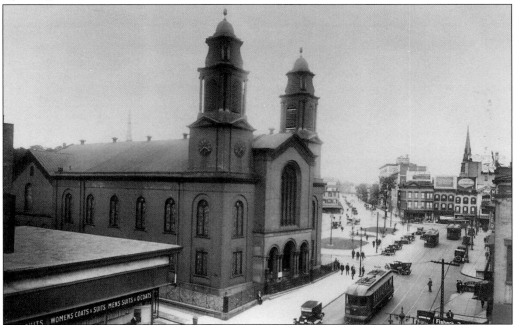

THE DUTCH REFORMED CHURCH. The oldest building in Albany is the Dutch Reformed Church, located on North Pearl Street between Monroe and Orange Streets. Built in 1798, the church was designed by Philip Hooker and is his earliest known work. The first church was erected in 1634 on Broadway and State Street.

CLINTON SQUARE. This photograph shows Clinton Square at North Pearl Street, east side. Proctor's Grand Theater, on the right on Clinton Avenue, has been replaced by the Federal Building. The Third Presbyterian Church, on the left, became the Clinton Square Theater, which showed silent movies. Notice the trolley and the cars competing for space. Every building pictured is now gone.

BATTERSBY'S. On the north side of Clinton Square at the corner of Clinton Avenue and North Pearl Street was Battersby's Clinton Market. For 70 years the market was there. Now the Palace Theater occupies the site.

THE HOME OF GANSEVOORT MELVILLE. Here is the home of fur dealer Gansevoort Melville, brother of author Herman Melville of Troy, who stayed here often and worked for a time as a clerk at the New York State Bank. Gansevoort was a fur dealer from 1834 to 1838. The house still stands at 3 Clinton Square.

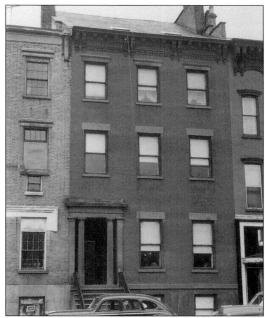

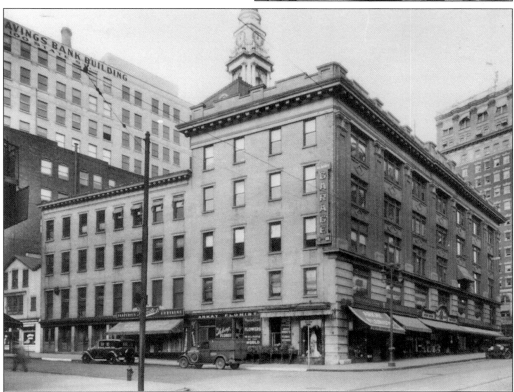

SOUTH PEARL AND HOWARD. This photograph shows South Pearl Street and the northwest corner of Howard Street. Formerly the Globe Hotel, the building was converted into the Arkay Building. To the right is the Ten Eyck Hotel, and to the far left is the Simmons Auction House.

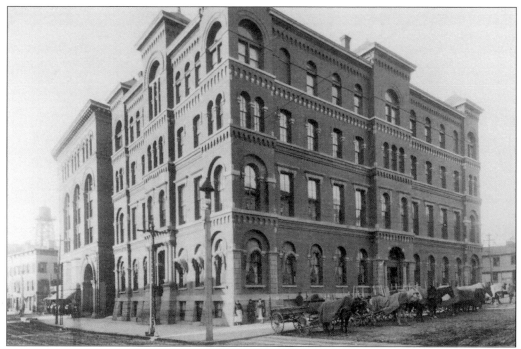

THE CITY MUNICIPAL BUILDING, 1897. This 1897 view shows the Albany Municipal Building on South Pearl Street at the southwest corner of Howard Street. The building was erected in 1868 on the site of the Ebenezer Lutheran Church. In 1998, archaeologists found a burial site in this area under Pearl Street.

SOUTH PEARL STREET. This photograph shows the northwest corner of Beaver and South Pearl Streets. South Pearl Street was originally a narrow irregular lane that led to the Ebenezer Lutheran Church and burial ground south of it and was bounded by the open Rutten Kill; a gate swung across it at State Street. Notice the large barber pole on Beaver Street. The city building is on the right.

MARTIN'S HALL. Martin's Hall, or Opera House, was located on the northwest corner of Beaver and South Pearl Streets. Erected in 1870, it was used for balls, meetings, theatrical shows, and musical events. It seated 1,306. The lower floors were used for offices and stores. The building was destroyed by fire in 1886.

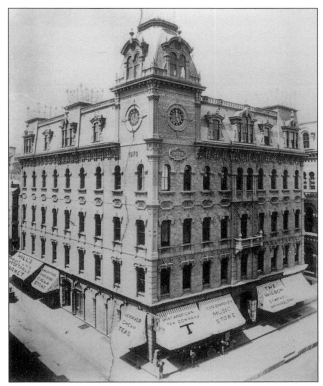

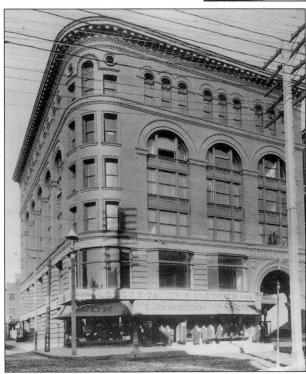

THE DEGRAAF BUILDING, 1897. This 1897 photograph shows the DeGraaf Building on the northwest corner of Beaver and South Pearl Streets. This commercial office building was next to the Albany Municipal Building and replaced Martin's Hall. Located in the DeGraaf Building was Dolan's Clothes Store.

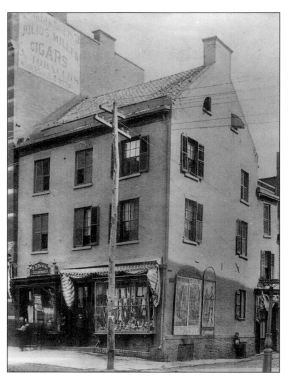

THE OFFICE OF AARON BURR. The office of famous duelist Aaron Burr was located in this wood-frame house at 24 South Pearl Street, on the northeast corner of Norton Avenue, called Store Lane, across from Martin's Hall. After his famous duel in 1804, Burr hid in the house of his friend Cadwallader Colden, at 534 Third Avenue in Lansingburgh.

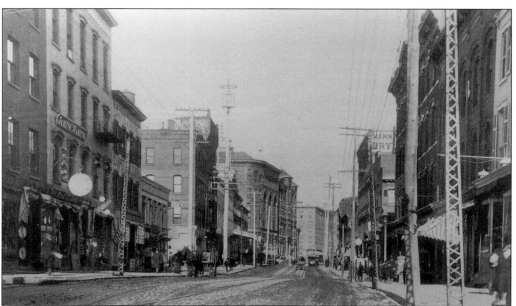

SOUTH PEARL STREET. This photograph of South Pearl Street was taken in 1897, looking north from Hudson Street. The city building and the DeGraaf Building are visible in the center, with Tweddle Hall at the end. Today, little remains of this section of Pearl Street. The Pepsi Arena, new commercial buildings, and a spaghetti-like maze of overhead arterial roads take up the space.

Two

TRANSPORTATION AND MOVEMENT

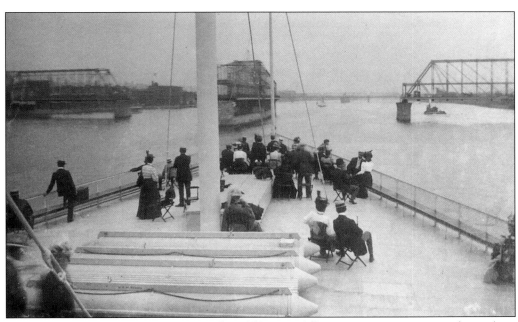

THE HUDSON RIVER, 1900. For more than 350 years, Albany was a river city, stretching along the mighty Hudson, which Henry Hudson discovered in 1609. The Hudson River was a major trade, transportation, and military route. In the 1970s, the river was cut off from the city by the development of the Interstate 787 interchange system. Pictured here are residents returning to Albany on the Hudson River day boat *New York* in 1900. The Greenbush bridge, now the Dunn Memorial Bridge, is open, and Albany is to the left. The *New York* was built in Wilmington, Delaware, by the Harlan and Hollingsworth Company. It was 311 feet long, 74 feet wide, and weighed 1,552.52 tons.

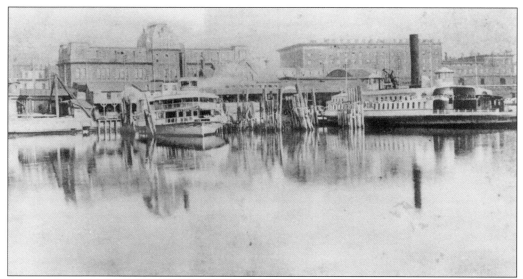

GREENBUSH FERRIES, c. 1860S. Ferry rights were given to Albany when the city was chartered in 1686. However, as early as 1642, a ferry crossed the Hudson River from Arch Street to the Greenbush landing in Rensselaer. This photograph of Greenbush ferries, off lower Ferry Street below Broadway, was taken *c.* 1860s, before there were any bridges in Albany.

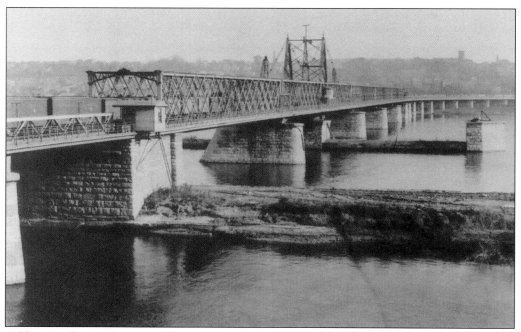

A HUDSON RIVER BRIDGE. Albany's second bridge opened in 1871 at the foot of Maiden Lane. Called the Lower Bridge, it was rebuilt in 1900 for the new Union Railroad Station. Albany's first bridge, the Upper Bridge, opened on February 22, 1866, on Livingston Avenue. Still there, it may be the only 19th-century bridge spanning the Hudson River today.

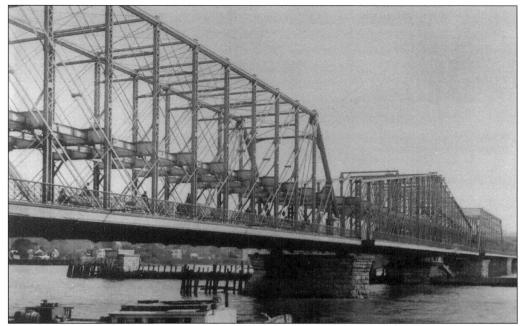

THE GREENBUSH BRIDGE. Albany's third bridge was located at the foot of Ferry Street. The Greenbush Bridge was begun in 1876 and was completed on January 24, 1882. It was replaced by the Dunn Memorial Bridge in 1933.

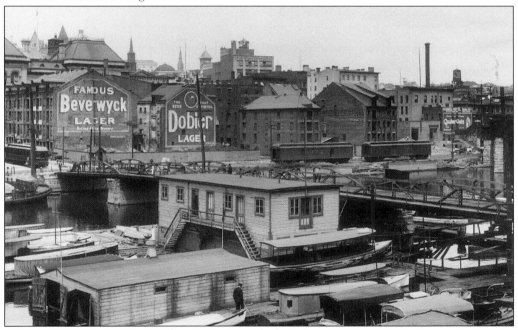

WATERFRONT DOCKS. Pictured are waterfront docks at lower State Street. On August 22, 1840, one of the bridge draws here fell and 21 people drowned. In 1880, boats could be rented here for 25¢ an hour, or at a lesser rate for the whole day. Notice Quay Street running alongside the river and the post office building at the top left. Interstate 787 now occupies this area.

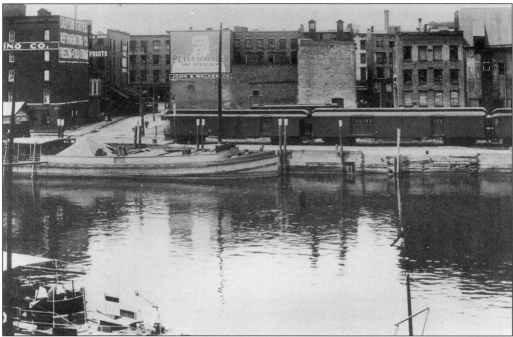

THE ALBANY BASIN. This photograph shows the Albany Basin, probably off Quay and Exchange Streets. The Albany Yacht Club rented boats, and youngsters swam here. The basin and the pier were built for the Erie Canal, which terminated in Albany. The project was completed on May 27, 1825. The basin could hold 1,000 canal boats and 50 larger vessels. It was 4,323 feet long, 85 feet broad, and had drawbridges at the foot of State and Columbia Streets, along with a sloop lock. The first canal boat came through on October 26, 1825.

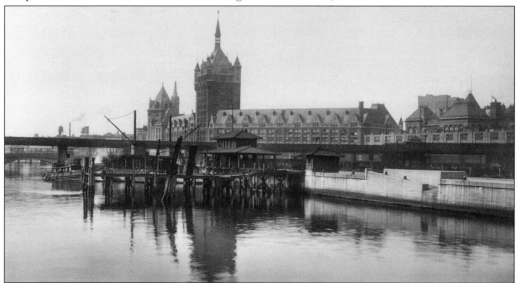

BASIN PIERS, c. 1920s. This c. 1920s view shows the piers for the Troy steamers. The ticket office is in the center, and the D&H Building and the post office are in the background. Notice the elevated Hudson River Bridge.

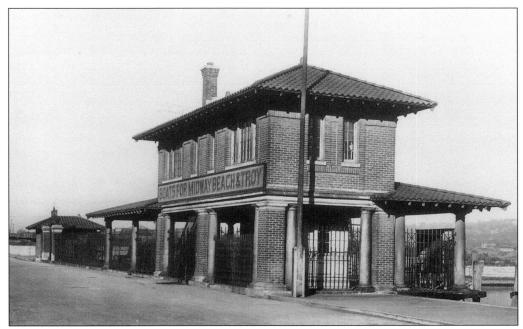

A TICKET OFFICE, 1947. This 1947 photograph shows the ticket office for boats going to Midway Beach and Troy. The office was located on Quay Street and Maiden Lane. Midway Beach was a large amusement park in Menands that went down to the river. It had a wooden roller coaster, and an island across from it had a racetrack.

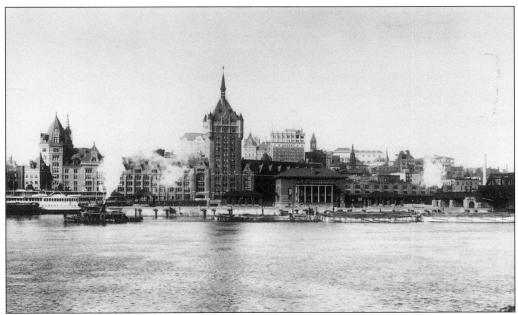

A RIVER VIEW FROM RENSSELAER, c. 1920. This *c.* 1920 view shows the Albany Yacht Club in the center. The yacht club was organized on April 16, 1873, and was incorporated in 1905. Notice the steamer *Robert Fulton,* a Hudson River day liner, docked on the left in the basin. In 1909, day liners left every morning (except on Sundays) at 8:30, from May 27 to October 25.

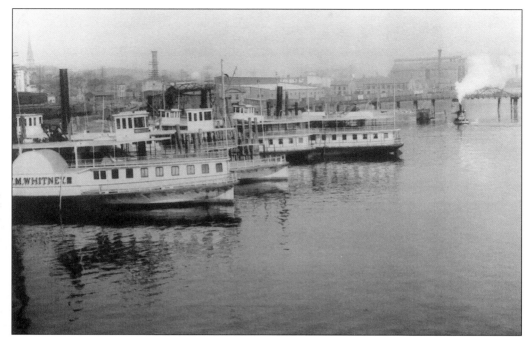

A VIEW SOUTH, 1891. The *W.M. Whitney* and other steamers are docked in this view taken in 1891 from the Hudson River Bridge. In 1909, there were seven steamboat lines operating out of Albany. Travelers also could still board a stagecoach at 9:30 a.m. at the post office and travel to Clarksville, Rensselaerville, and intermediary places.

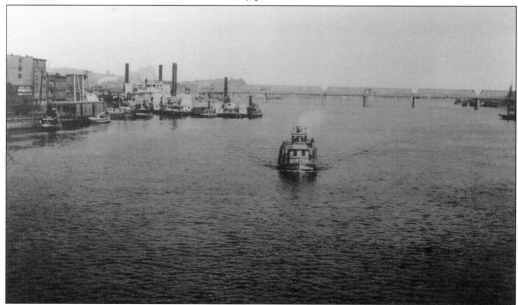

A VIEW NORTH, 1891. This photograph was taken in 1891 from the Greenbush Bridge. The Hudson River Bridge is visible in the background, steamers are at the dock, and a tugboat is in the center. Tugs could pull quite a load. On May 26, 1862, the steam tug *Cayuga* reached Albany with 67 boats in tow—the largest number ever brought up the Hudson River.

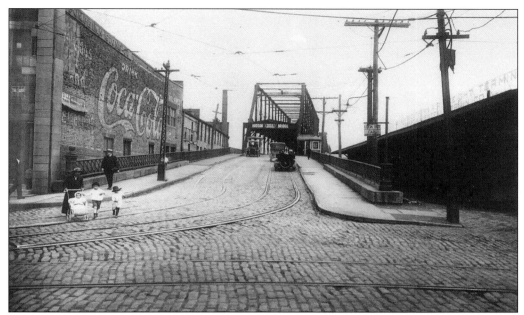

THE GREENBUSH BRIDGE ENTRANCE. This bridge, also called the Hudson Bridge, is shown here from the foot of Ferry Street. Note the two signs: one of them says "Free Bridge" (most bridges were originally toll based), and the other warns "look out for cars." The bridge was replaced by the Dunn Memorial Bridge, which opened in 1933.

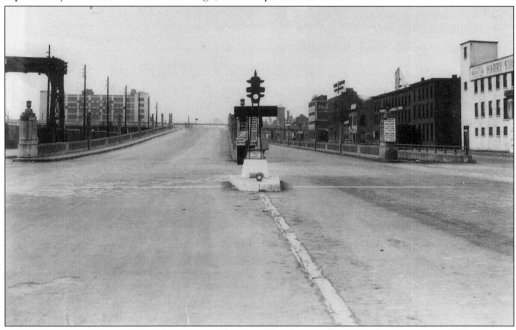

BROADWAY RAMP, 1930. This 1930 photograph shows the Broadway ramp to the Dunn Memorial Bridge. The building at the back left still exists; it was originally the Albany Hardware & Iron Company and is now the U-Haul Company. The buildings on the right are gone. Fort Orange is buried immediately to the left of this view.

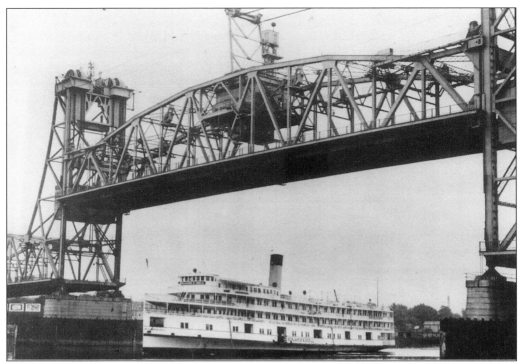

THE DUNN MEMORIAL BRIDGE. The Dunn Memorial Bridge opened in 1933. The *Benjamin D. Odell* was the first steamer to pass under the new bridge. This bridge has been replaced by the current one.

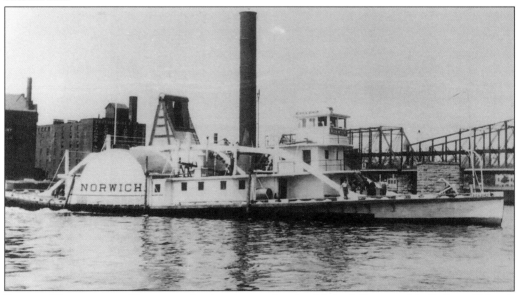

STEAM NAVIGATION. Steam navigation began in the United States with Robert Fulton's *Clermont* in 1807. In 1812, the *Fire-fly* began running between Albany and Troy twice a day. The *Norwich* was one of the oldest steamboats running. Built in 1836, it was still making trips in 1909.

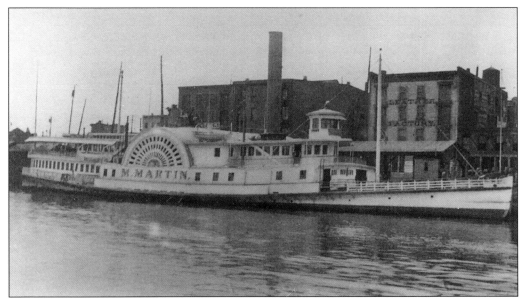

THE MILTON MARTIN. The *Milton Martin* made its first trip from Catskill to Albany on April 11, 1864. It was used by Gen. Ulysses. S. Grant as his dispatch boat on the James River in the Civil War. On June 28, 1865, the 5th New York Artillery was encamped at Steamboat Landing when one of its members fell into the river and drowned. Howard W. Arthur accidentally fell overboard as he was spreading his blanket for sleep

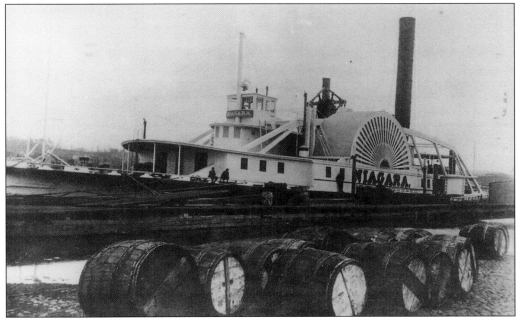

THE NIAGARA. There were two boats named the *Niagara:* one in 1826 and one in 1845. On July 31, 1847, four people were killed when the *Niagara* blew up near Ossining.

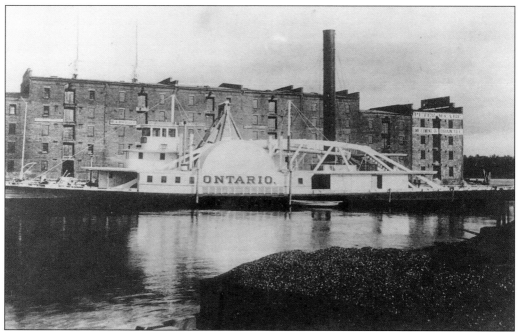

THE ONTARIO. In 1833, the Hudson River Association Line was formed by combining the Hudson River Line (1825), the North River Line (1826), and the Troy Line (1832). This association sailed three day boats and three night boats.

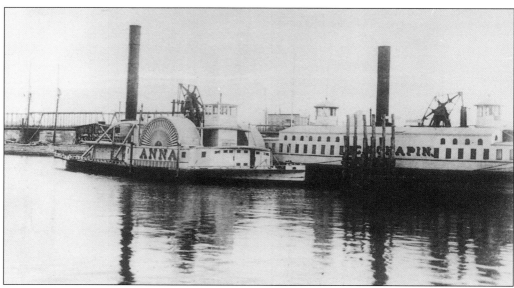

THE ANNA AND THE C. CHAPIN. The *Anna* and the *C. Chapin* were two of the 12 boats that carried passengers to and from Albany in 1826. The 12 boats were operated by six different companies: the Steam Navigation Company, the Union Line, the North River Line, the Connecticut Line, the North River Association Line, and the Transportation Company Line.

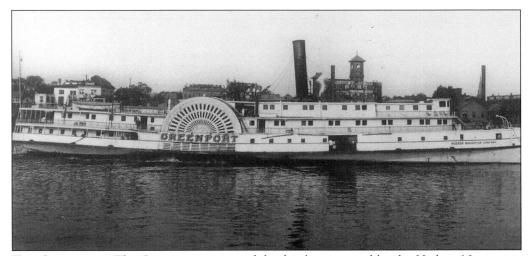

THE GREENPORT. The *Greenport* was one of the five boats owned by the Hudson Navigation Company. This line also owned the *Trojan, Rensselaer, Fort Orange,* and *Berkshire.* The last two ran only to Albany from Troy.

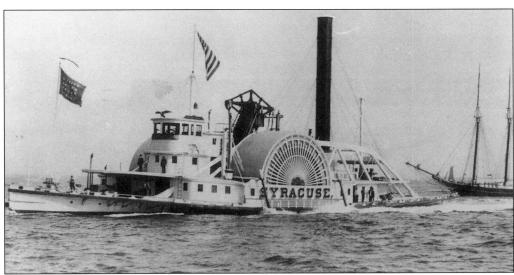

THE SYRACUSE. This photograph shows the *Syracuse* plying the Hudson River during the Hudson Fulton Celebration of 1909.

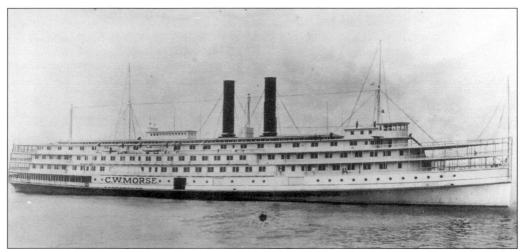

THE **C.W. MORSE.** This is a view of the *C.W. Morse*, a Hudson River day liner.

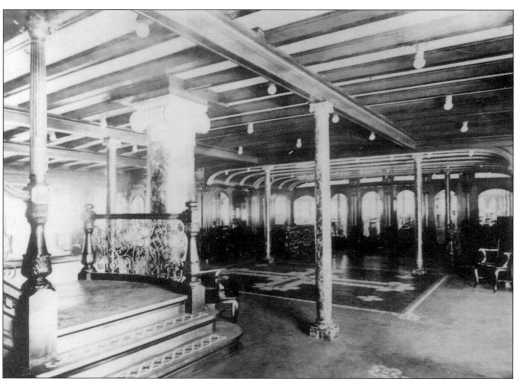

THE **LOBBY ENTRANCE.** This photograph shows the lobby entrance of the *C.W. Morse*. Steamboats were created to impress as well as to move people.

THE SOCIAL HALL. Pictured here is the social hall of the Hudson River day liner *C.W. Morse*.

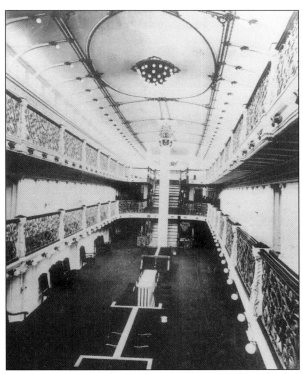

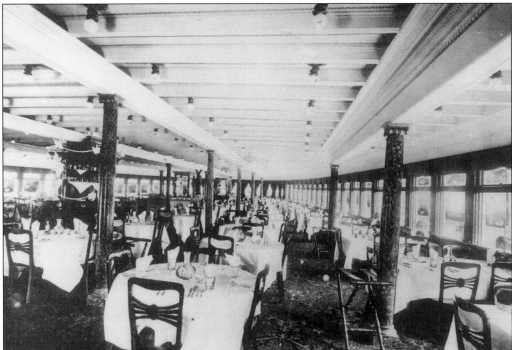

THE DINING AREA. The dining area of the Hudson River day liner *C.W. Morse* included space for an orchestra. It was common for a steamer to have an orchestra aboard for entertainment.

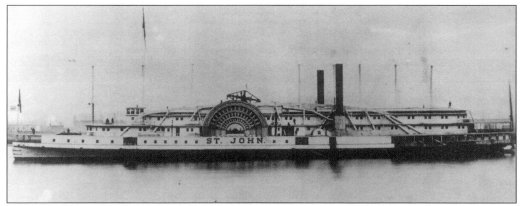

THE *ST. JOHN*. The People's Line steamer *St. John* arrived from New York for the first time on March 17, 1864. The People's Line was established in September 1834 to compete with the Hudson River Association but sold out to them in 1835. Daniel Drew revived the People's Line in 1836, and within 25 years had several boats, including the *St. John*. On October 29, 1865, a boiler exploded on board, killing 11 passengers and injuring 15 others. The *St. John* returned to service on November 9, 1865.

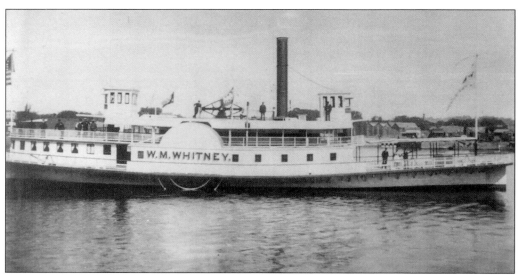

THE *W.M. WHITNEY*. The *W.M. Whitney* was named after a well-established Albany merchant on North Pearl Street.

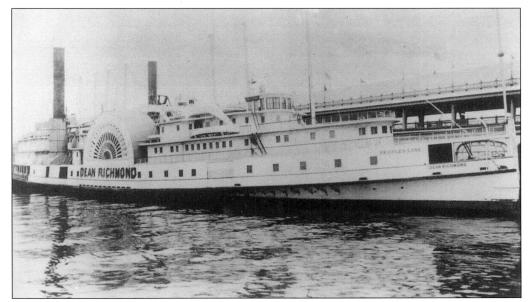

THE *DEAN RICHMOND*. The *Dean Richmond* first arrived on the river on July 20, 1865. It was named after the president of the New York Central Railroad. The boat was 370 feet long and had 900 first-class and 600 second-class rooms. It left Steamboat Landing in Albany each day at 8:00 p.m. and left Pier 41 in New York City at 6:00 p.m. The *Drew*, another Peoples' Line steamer, first appeared on April 24, 1867. It was 400 feet long and 80 feet wide. It sank on September 20, 1867, after colliding with the *Vanderbilt*.

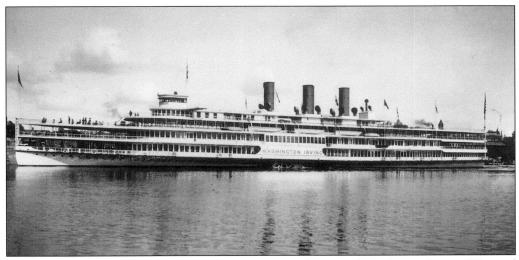

THE *WASHINGTON IRVING*. By 1885, there were 53 sailing vessels, 113 steamboats, 175 canal boats, and 86 barges on the river. Among them was the *Washington Irving*.

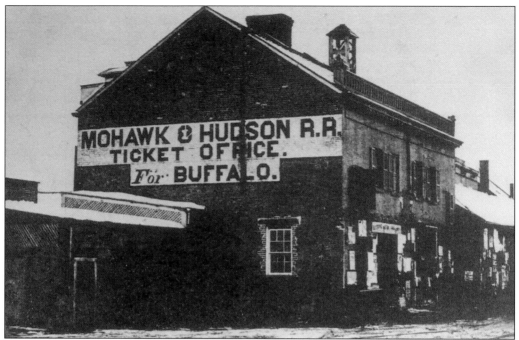

THE MOHAWK & HUDSON, c. 1860. This c. 1860 photograph shows the Mohawk & Hudson River Railroad ticket office at South Ferry Street and Broadway. The first steam-powered passenger train in New York State ran between Schenectady and Albany through the Pine Bush. Incorporated in 1826, the train it made its media voyage on September 24, 1831, with prominent Albany citizen Erastus Corning aboard. An original section of roadbed still exists on Washington Avenue but is in danger of being destroyed.

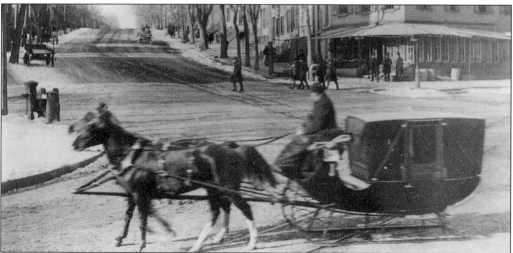

CLINTON SQUARE. The view of Clinton Avenue and North Pearl at Clinton Square was taken looking west up Clinton Avenue. The building on the corner is where the Palace Theater now sits. Before the development of trolleys, citizens moved around in buggies, wagons, and sleighs, as seen here. Several carriage factories existed in Albany. Clinton was originally called Patroon Street since it was the northern boundary between Albany and the manor of Rensselaerwyck.

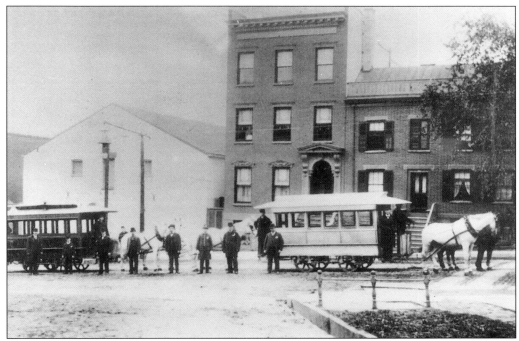

HORSE-DRAWN TROLLEYS, 1890. This photograph of horse-drawn trolleys on Clinton Avenue and Ten Broeck Street was taken October 26, 1890. The car on left was used in 1878, and the one on right was used in 1873. The house in the center is still standing.

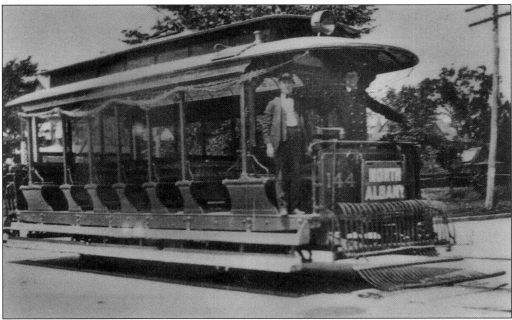

THE LAST OPEN TROLLEY. Trolley No. 144 of the North Albany Line was the last open trolley to run in Albany. Trolleys were replaced by buses in 1946.

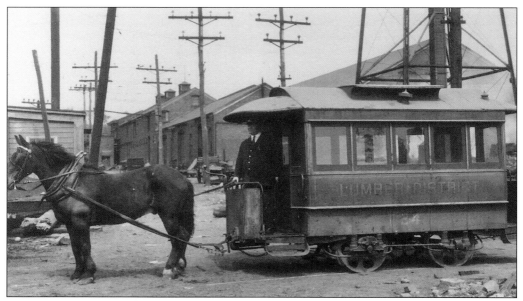

A HORSECAR, 1915. This 1915 photograph shows a horsecar driven by H.J. McMahon in the Lumber District. This trolley line was abandoned in 1921 after some of the track was torn up during the trolley strike of that year. The Lumber District was a section along the Erie Canal, what is now Erie Boulevard, from Lawrence Street to North Street. Along the east side of the canal were water cuts where boats loaded with lumber could be loaded and unloaded. Albany was the terminus for the Erie Canal, which opened in 1825. Almost 2,000 boats used the canal annually.

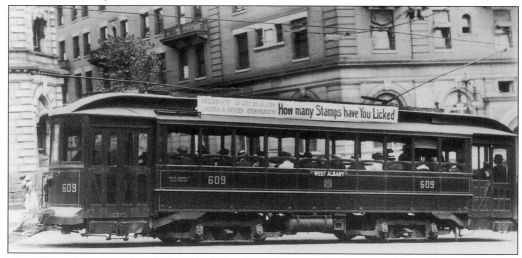

THE WEST ALBANY NO. 609, 1917. This 1917 photograph shows the United Traction's West Albany No. 609 passing the Ten Eyck Hotel and the Albany Savings Bank on State Street. Only 29 years later, in August 1946, trolleys ceased to run in Albany, replaced by buses. The United Traction Company was formed in 1899 by merging the Albany Railway Company, the Troy City Railway, and the Watervliet Turnpike and Railway Company (Albany-Troy and Albany-Cohoes line through Watervliet), and Albany's last horsecar line, the Lumber District Line. United Traction was bought by D&H in 1906.

Three

INSTITUTIONS
PUBLIC AND PRIVATE

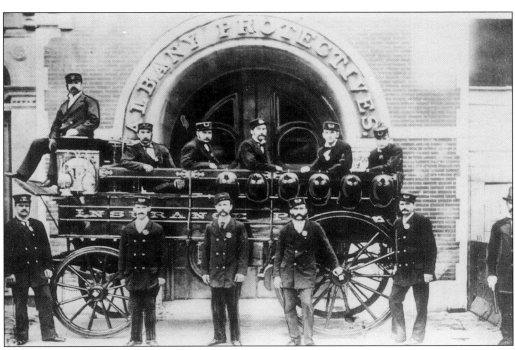

THE ALBANY PROTECTIVES. The Albany Protectives, also known as the Insurance Patrol, was a private fire department of the 1870s. The department was sponsored by the insurance companies. It was in existence as late as the 1960s. It was famous for its yellow fire truck and Dalmatian mascot. The city had a fire department in 1694 called Brand-masters who used hooks and brantleere, or fire ladders. In December 1706, six "fyre-masters" made up the department. In 1793, a fire destroyed most of the area from State and James Streets to Broadway.

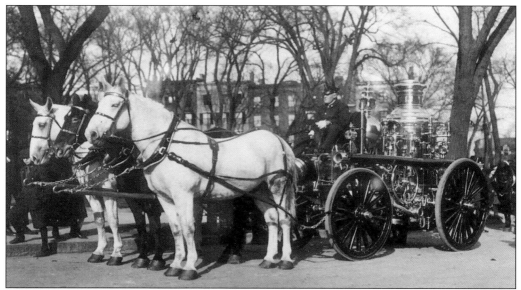

A STEAM PUMP. In February 1732, Albany got its first hand pump and housed it in a shed at the corner of Beaver and South Pearl Streets. On January 26, 1801, the Hand Barrow Company was organized. In 1825, the Albany Fire Department had ten fire engines, two hook & ladder companies, and one ax company. On August 17, 1848, the Albany Basin and Pier and about 600 houses covering 37 acres burned. The fire covered the area of Herkimer, Dallius, Union, Hudson, and Quay, the most densely populated part of the city. It was not until July 13, 1863, that Albany got its first steam engine.

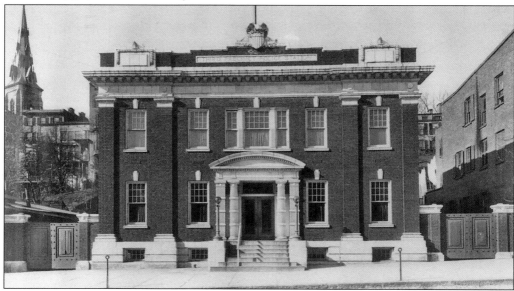

THE POLICE STATION. This is the 3rd Precinct police station on the west side of North Pearl Street, near Livingston Street. Albany had no organized police force until 1851. Before that, crime in the city was handled by constables. On January 7, 1861, Police Chief Amos Adams reported that the previous year's arrests numbered 4,698. The city was divided into five precincts. This building is now boarded up.

THE CATHEDRAL OF THE IMMACULATE CONCEPTION, 1891. This 1891 photograph shows the Cathedral of the Immaculate Conception on the west side of Eagle Street, at the southwest corner of Madison Avenue. Dedicated in 1852, the church was a prominent feature in the Albany skyline and is still here today. Most of the neighborhoods surrounding it were demolished for the massive Nelson Rockefeller Empire State Mall.

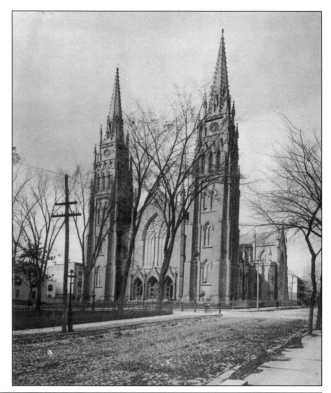

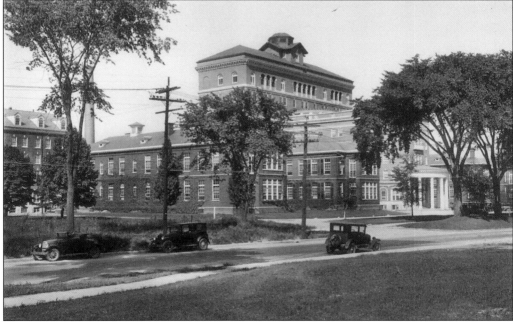

THE ALBANY MEDICAL HOSPITAL. The Albany Medical Hospital was incorporated in April 1849. The hospital's main building was erected in 1898 on New Scotland Road. Today, the hospital is one of the country's leading medical institutions.

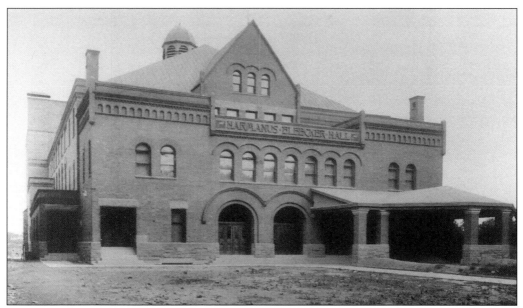

HARMANUS BLEECKER HALL. Harmanus Bleecker Hall was built by the YMCA in 1888 at 161 Washington Avenue, the site of the current Albany Public Library. Harmanus Bleecker was an ambassador to the Netherlands.

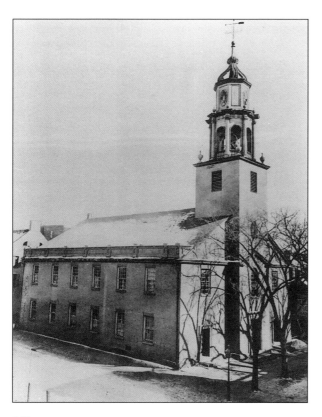

THE FIRST PRESBYTERIAN CHURCH. The First Presbyterian Church was constructed in 1794 at the corner of Beaver and South Pearl Streets. This was the church's second building.

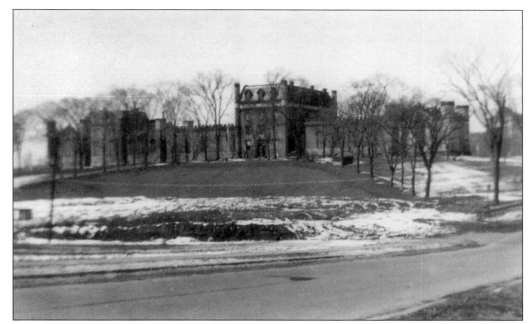

THE ALBANY PENITENTIARY. The Albany Penitentiary was incorporated in 1844. Built by inmates, the penitentiary opened in 1846 south of Washington Park, at the corner of New Scotland and Myrtle Streets, where the Veterans Hospital is now.

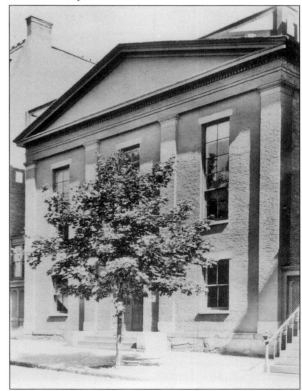

THE ALBANY LAW SCHOOL. The Albany Law School was organized in 1851. At the time, there were only three other law schools in the country: Harvard, Yale, and Columbia. This building on State Street west of Swan Street was the old Universalist Church. It was first used by the law school in 1879. Pres. William McKinley was an Albany Law School graduate.

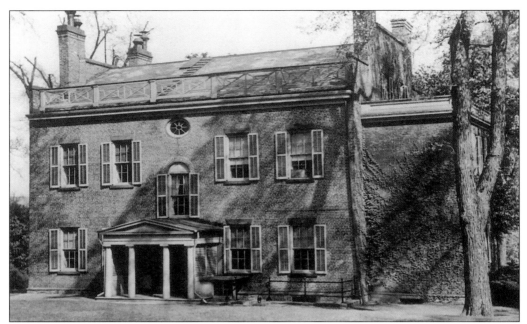

THE TEN BROECK MANSION. This Federal brick residence is the Ten Broeck Mansion. It was built in 1797-98 at 9 Ten Broeck Place for Abraham Ten Broeck. Ten Broeck was a prominent Albany resident who was a delegate to the Continental Congress, a mayor of Albany, and a brigadier general in the American Revolution. Philip Hooker was the architect. The Albany County Historical Association maintains the house as a museum, which is open to the public.

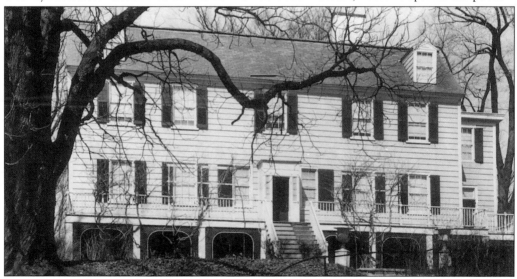

CHERRY HILL. This gambrel-roofed, Georgian-style house was built in 1787 as the home of Philip and Maria Van Rensselaer. Called Cherry Hill, the house at 523 South Pearl Street was home to four generations of Van Rensselaers, until 1963. It is now a museum under the auspices of the Friends of Cherry Hill. The Van Rensselaers were some of Albany's wealthiest and most influential people. Among them were merchants, geologists, war heroes, congressmen, physicians, and lawyers.

104

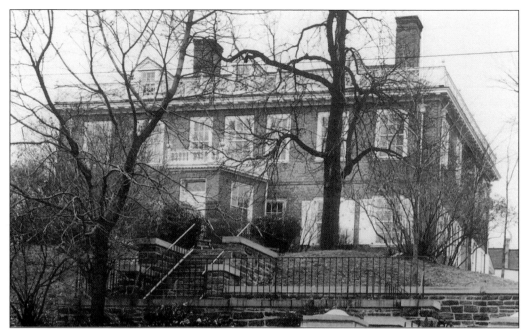

THE SCHUYLER MANSION. The Schuyler Mansion was the home of Maj. Gen. Philip Schuyler (1733-1804) who served during the American Revolution. Erected in 1762 on the corner of Catherine Street and Clinton Avenue, the house was where the defeated Gen. John Burgoyne stayed after his capture. Pres. Millard Fillmore was married here. The house was acquired by New York State in 1911. It was restored and dedicated on October 17, 1917. A state historic site, it is open to the public.

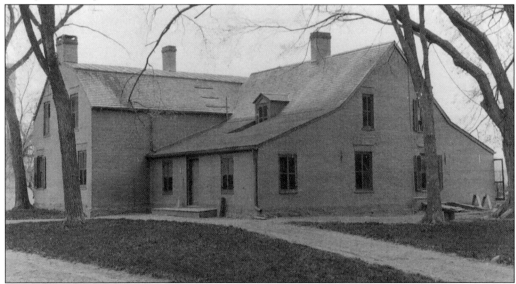

THE FLATS. Schuyler Flats was Maj. Gen. Philip Schuyler's country home. Ann Grant's *Memoirs of an American Lady* were based on her stay at this house.. All the tombstones here were relocated to the Albany Rural Cemetery. After a fire struck the property, plans got under way to develop the site into a park.

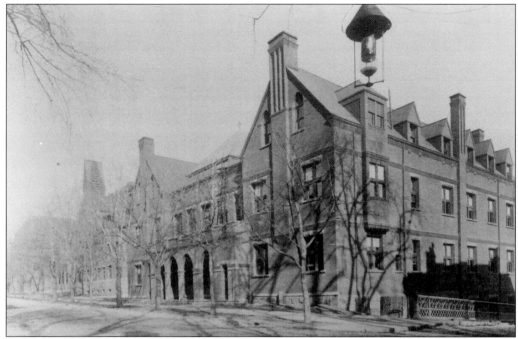

CHILDS HOSPITAL. This photograph shows Childs Hospital, on Elk and Hawk Streets. The hospital first opened to treat patients in March 1875. The original hospital was located in a small building on Lafayette Street. The facility later moved to a larger house on Elk Street. In 1877, a small hospital was built; then in 1891, the present building was erected on the site of the demolished Townsend Iron Furnace Works. Childs Hospital still exists.

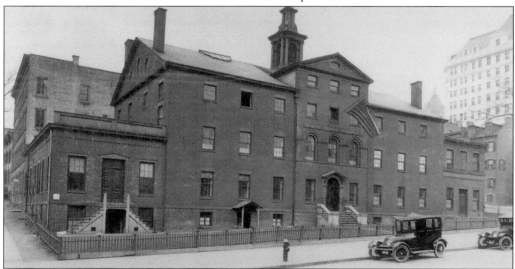

THE ALBANY MEDICAL COLLEGE, c. 1919. This photograph shows the Albany Medical College , located on Eagle Street between Jay and Lancaster Streets. Dr. Alden March opened a school for the study of anatomy in Albany in 1821. In 1838, the city leased this unoccupied 1817 Lancastrian School for a medical school. The first classes were held on January 3 1839. The college is now part of the Albany Medical Center.

THE NURSES TRAINING SCHOOL, c. 1910. This c. 1910 photograph shows the National Training School for Certified Nurses, located at 285 Lark Street. The British army trained Albany women to become nurses during the French and Indian War. Nurse training has been going on in Albany for more than 200 years; the city is certainly one of the oldest, if not the oldest training center in the country. Several nursing schools are located in Albany today. This building still stands. A stained-glass window bearing the words "Class of 1923" was removed from over the entrance and was sold to an antique dealer.

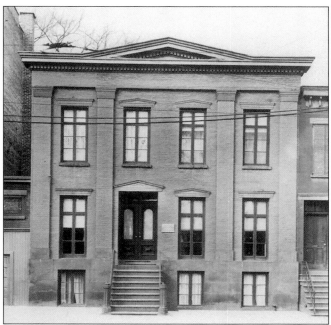

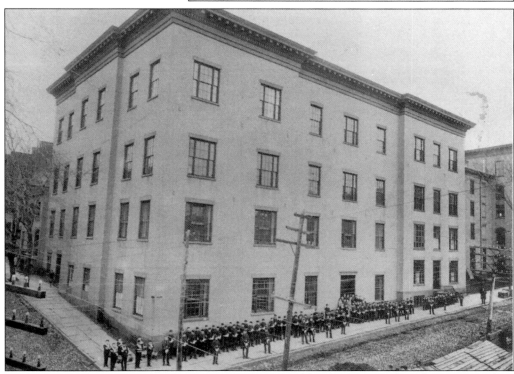

THE CHRISTIAN BROTHERS ACADEMY, 1897. Pictured here in 1897 is the Christian Brothers Academy at 43 Lodge Street. The academy was founded in 1864 as a Catholic institution to train young boys. It is still serving that purpose in another building located off New Scotland Avenue.

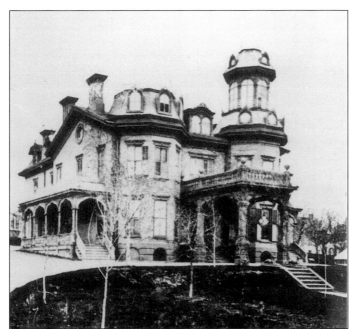

THE GOVERNORS MANSION, 1888. For more than 100 years, this building at the corner of Eagle and Elm Streets has served as the residence of New York's governors. Shown here in 1888, the Governors Mansion has since been remodeled.

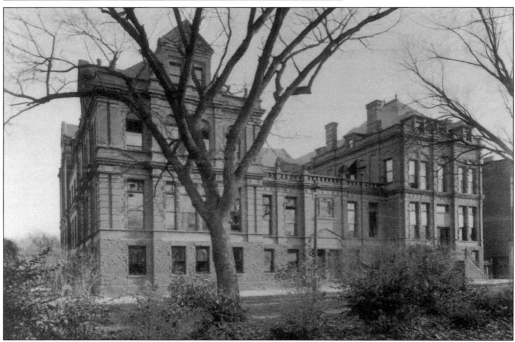

THE STATE NORMAL SCHOOL, 1891. This 1891 photograph shows the State Normal School on Willett Street across from Washington Park near Madison Avenue. Established on May 7, 1844, the school opened with 29 students in December 1844 in the old Mohawk & Hudson Railroad building at 119 State Street. It moved to Lodge Street in 1848 and then to this building in 1885. Destroyed by fire, the college was replaced by the State Teachers College on Western Avenue, now the University at Albany.

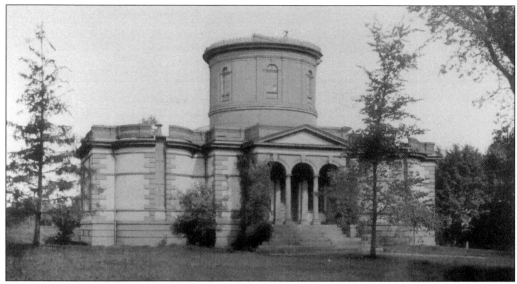

THE DUDLEY OBSERVATORY. The Dudley Observatory was incorporated in 1852. The first building, near Washington Park, was formally dedicated in August 1856 under the auspices of the American Association for the Advancement of Science, started by renown physicist Joseph Henry of Albany. The observatory had a 13-inch refractor telescope. A second building was erected on South Lake Avenue and New Scotland Avenue in 1892-93 and was dedicated by the National Academy of Science. That building was torn down in late 1960s. In its day, the observatory contributed a great deal to astronomy. Today, it is located in Schenectady.

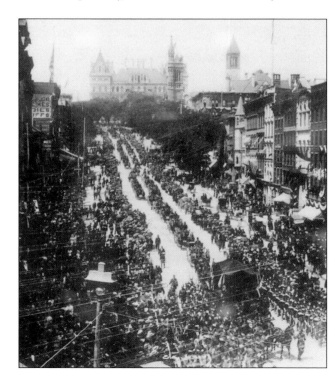

GRANT'S FUNERAL, 1885. A procession went down State Street during the funeral of Pres. Ulysses S. Grant. Grant served as the country's 18th president from 1869 to 1877. He died in 1885 at Grant's Cottage, not far from Albany. Pres. Abraham Lincoln was also brought to Albany and viewed at rest on April 26, 1865.

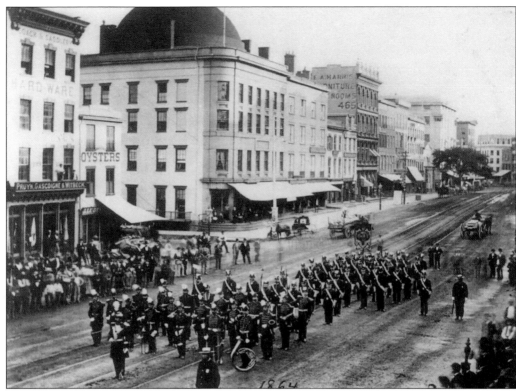

THE MASONS' TEMPLE COMMANDERY, 1864. This 1864 photograph shows the Masons' Temple Commandery No. 2 marching along Broadway. Stanwix Hall, now the post office building, is on the left, at the corner of Maiden Lane.

WASHINGTON PARK, 1923. Albany's 300th anniversary pageant is shown here in Washington Park in 1923. Prior to 1870, the park was the Washington Parade Ground, burial ground, and residential area, and was bounded by Willett, Madison, State, and Robin Streets. In 1882, more land on Madison and Lake was added. Having fun was not always easy in Albany. In 1880, playing ball and shinny in the public streets was punishable by a fine of $1 per person. Throwing ashes or begging was also a crime. In 1713, children were not allowed to sleigh down any hill within the city. Constables were allowed to smash sleds at the scene of the "crime."

A REPLICA OF THE HALFMOON. A replica of the *Halfmoon,* explorer Henry Hudson's ship, appeared on the Hudson River during the Hudson Fulton Celebration of 1909. The replica was given to city of Cohoes and was moored at Van Schaick Island. After it was abandoned, squatters started a fire inside it to keep warm and the boat burned.

THE HUDSON FULTON CELEBRATION. As part of the Hudson Fulton Celebration of February 1909, a "living flag" was formed on the steps of the capitol. Two years later, in March 1911, the capitol burned, resulting in an estimated $5 million in damage.

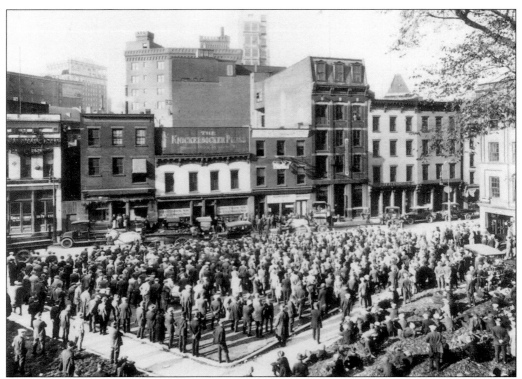

THE WORLD SERIES. This 1912 photograph shows a crowd listening to a World Series baseball game on an outdoor sound system at Hudson Street below Green Street. Liberty Park is still there, but the buildings are gone.

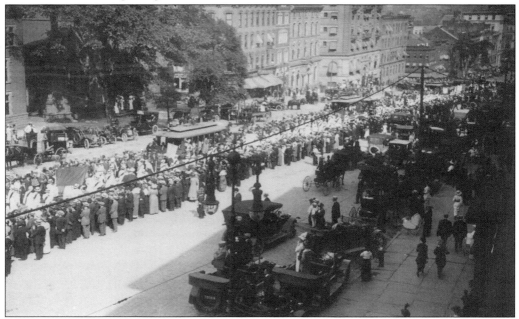

A SUFFRAGETTE PARADE. Here is a view of the June 6, 1914 suffragette parade on State Street.

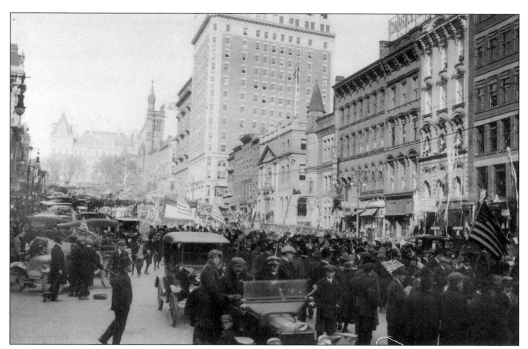

ARMISTICE DAY, 1918. This view of State and North Pearl Streets was taken on Armistice Day at the end of World War I, November 11, 1918.

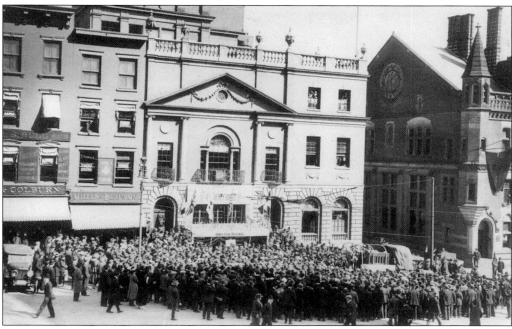

A LIBERTY LOAN DRIVE. This was the fourth Liberty Loan drive during World War I, on State Street in front of the State Bank, at the corner of James Street. Notice that the facade for State Bank is now incorporated in the Fleet Bank building on the corner of North Pearl and State Streets. The Mechanics & Farmers Bank, on the right, was constructed in 1874-75.

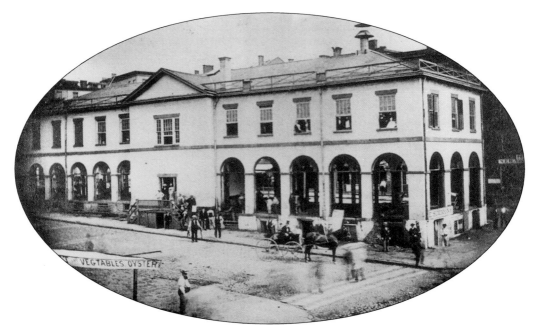

THE WASHINGTON HAY MARKET, 1860. This 1860 view shows the Washington Hay Market on South Pearl Street. The market was located on the site of the former Lutheran church, where the city municipal building was later erected. The police court was on the second floor of the market, and rooms and stalls were rented on the the first-floor and basement levels.

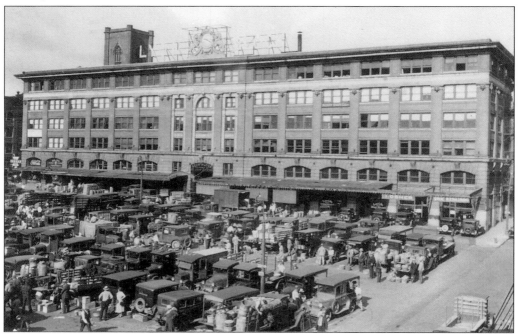

THE MARKET BLOCK. The Market block, or Lyon Block, was located at 99–109 Hudson Street. The block was bounded on the north by Beaver Street, on the south by Hudson Street, and on the east by Grand Street. Eventually, the block was torn down.

Four

RECREATION

THE PINE BARRENS. The western limits of Albany contain a unique and endangered wilderness known as the Pine Bush. Thousands of acres of this ecosystem lie within the city borders and have been the subject of controversy for the last 30 years. Some 3,000 acres are under preservation. The Pine Bush is the home of the endangered Karner Blue Butterfly. Notice the parabolic sand dunes, the railroad tracks in the middle, and Central Avenue on the right.

BEAVER KILL OR BUTTERMILK FALLS. Beaver Kill, or Buttermilk Falls, was once a beautiful park. Today, only the ravine is still there. In the 19th century, some protest arose over the destruction of the waterfall. The city appropriated money for a park, but that park never became a reality. Today, the area is part of Lincoln Park.

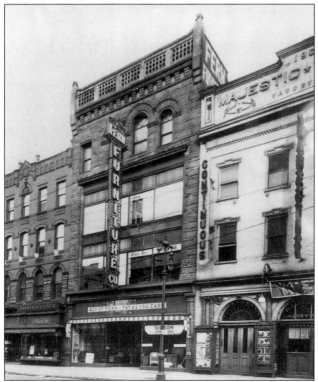

THE MAJESTIC THEATER, 1914. The Majestic Theater, shown here in 1914, was a vaudeville house established in 1909 on South Pearl Street between Hudson and Beaver Streets. Albany had several vaudeville houses and later motion picture houses. Today, there are none in the downtown area.

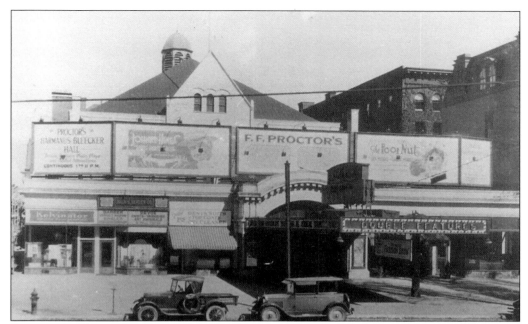

PROCTOR'S HARMANUS BLEECKER HALL, c. 1910. F.F. Proctor established vaudeville and movie houses in Troy, Schenectady, and Albany. This *c.* 1910 photograph shows the renovated Harmanus Bleecker Hall at 161 Washington Avenue. This movie house burned in 1939.

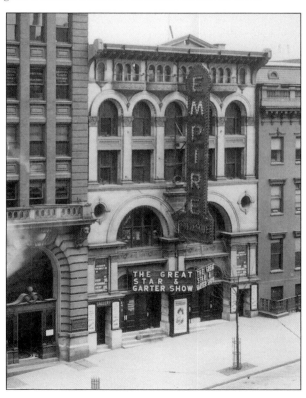

THE EMPIRE, c. 1920s. The Empire was a burlesque house on State Street west of South Pearl Street. The marquee in this *c.* 1920s photograph reads, "The Great Star & Garter Show." The Albany City Savings Bank building is on the left. When that bank combined with the County Savings Bank, the Empire was torn down. The house to the right of the theater was the home of prominent citizen Erastus Corning.

THE LELAND, 1929. On the west side of South Pearl Street between Beaver and Hudson Streets was the Leland. In this 1929 view, the building to the left is the original Albany Theater, designed by Philip Hooker and built in 1825. In 1966, a parking lot was built here.

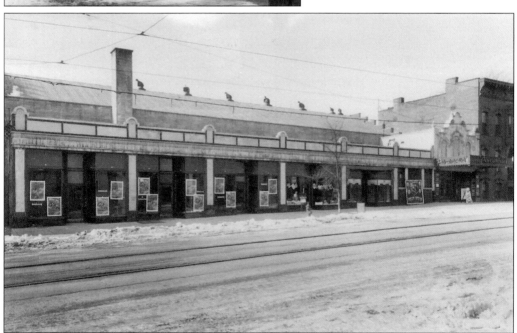

THE PARAMOUNT THEATER, c. 1930S. This c. 1930s photograph shows the Paramount Theater, located at 378 Clinton Avenue, south side, below Lexington Street. Today, the building is being reused.

THE ALBANY THEATER, 1926. This 1926 view shows the Albany Theater at 69 North Pearl Street between Steuben and Columbia Streets. The building is still there. It has one of only two cast-iron facades in the city.

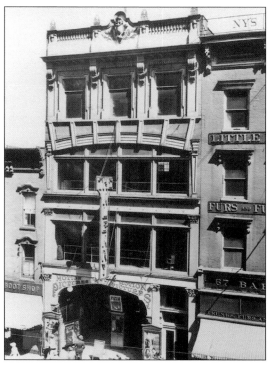

THE RITZ. The Ritz was located at 21 South Pearl Street, west side. It is the refitted old city building on the corner of Howard Street.

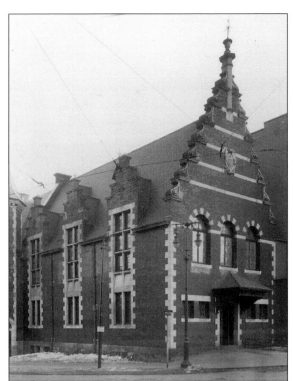

THE JOHN V.L. PRUYN LIBRARY.
The John V.L. Pruyn Library stood on the corner of North Pearl Street and Clinton Avenue. John V.L. Pruyn was chancellor of the State University of New York. His daughter Kitty Rice had the library built in 1907 in his memory. Albany has several excellent libraries. This one was torn down to make way for an exit ramp for Interstate 787.

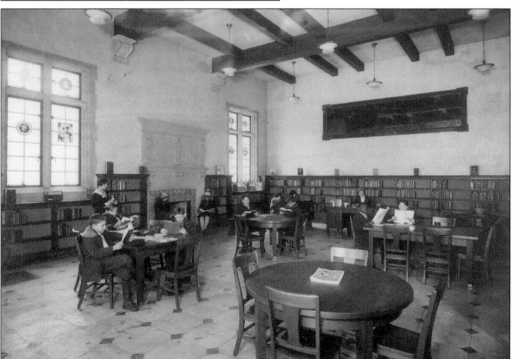

THE CHILDREN'S ROOM. This *c.* 1928 view shows the children's room of the Pruyn Library.

WASHINGTON PARK. In 1869, the old Washington Parade Ground and burial ground was approved for development as a park. In 1871, it opened as Washington Park. The park has changed and been expanded over the years. This photograph was taken looking toward Madison Street.

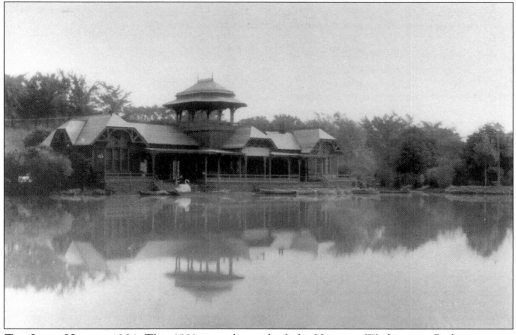

THE LAKE HOUSE, 1891. This 1891 view shows the Lake House at Washington Park.

THE BRIDGE AT WASHINGTON PARK. This photograph shows a seated man and two women standing on the bridge over the lake at Washington Park.

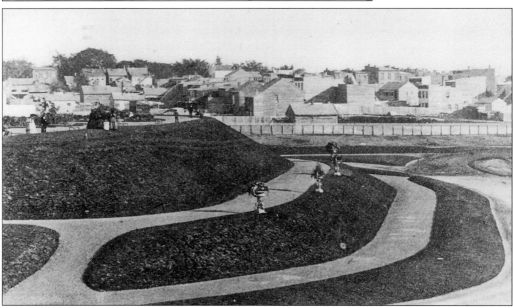

WASHINGTON PARK TERRACE, c. 1869. This photograph of Washington Park Terrace was taken c. 1869 looking east toward Lake View Terrace, Hamilton Street, Hudson Street, and Knox Street. Park Terrace was opposite the Lake House. To clear the land, the park commission auctioned off some 60 homes on May 27, 1880. In the weeks that followed, the homes were moved down Albany streets on rollers to new locations. The land was converted to a park. At the time, the planting or maintaining of cottonwood trees in Albany was punishable by three months in the Albany Penitentiary.

Five

DISASTERS

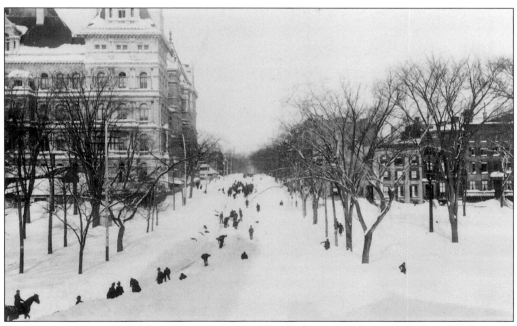

THE BLIZZARD OF 1888. This photograph was taken looking west from city hall up Washington Avenue. The capitol is on left. The buildings on right were replaced by the State Education Building in 1912–13. More than 4 feet of snow fell on March 13, 1888.

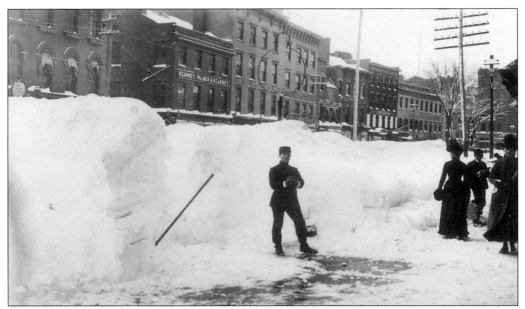

MARCH SNOW. This view of North Pearl Street near Maiden Lane was taken looking along the west side of the street after the Blizzard of 1888.

FOUR FEET DEEP. The Blizzard of 1888 did not spare North Pearl Street. This view was taken looking along the east side of North Pearl, past Maiden Lane. A pillar of the Female Academy is visible on the left.

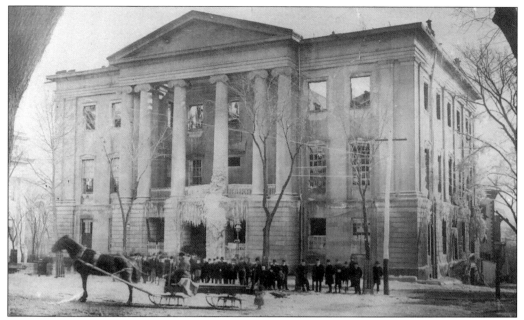

THE CITY HALL FIRE. Built in 1830, this city hall was destroyed by fire on February 10, 1880. The present-day city hall was quickly built to replace it.

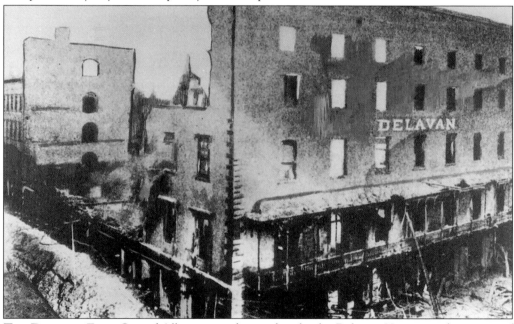

THE DELAVAN FIRE. One of Albany most famous hotels, the Delavan House, on the corner of Broadway and Columbia Streets, was packed with guests to celebrate New Year's when it burned on December 30, 1894. Sixteen people died. On January 3, 1866, a judgment against the city was awarded to the owner of the Delavan. To satisfy the judgment, the sheriff took over the common council chambers and emptied it of contents, including portraits of governors, desks, chairs, and other items.

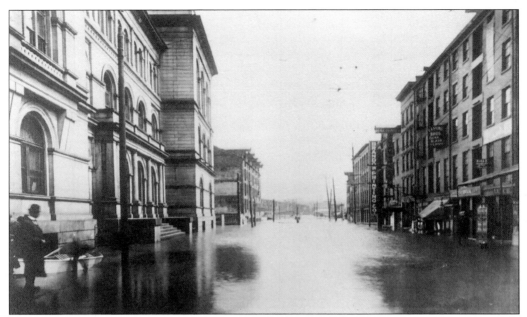

THE FLOOD OF 1913. One of the area's worse floods occurred in 1913. The Hudson River rose 28 feet above flood level. This is a view of lower State Street, with the post office on the left. Today, the D&H Building and Plaza are located in the area shown on the right.

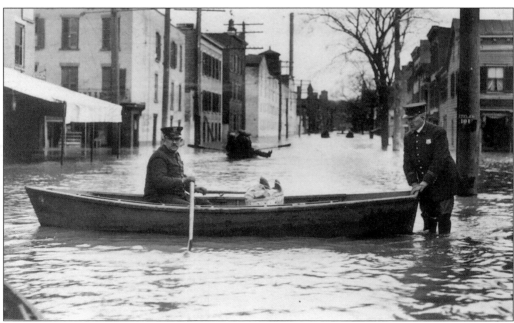

ROWING ALONG. During the Flood of 1913, Arch and South Pearl Streets were filled with water and with boat traffic.

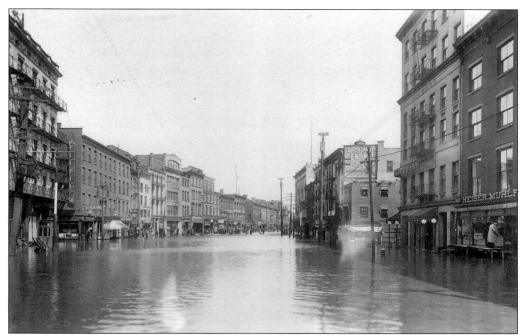

THE FLOOD OF 1936. Only 23 years after the Flood of 1913, Albany was covered by another flood of similar proportions. This view shows Broadway below State Street, west side, during the Flood of 1936. Keeler's Hotel is on the left. The Stanwix Hotel is on the right, on the corner of Maiden Lane, a site now occupied by the post office.

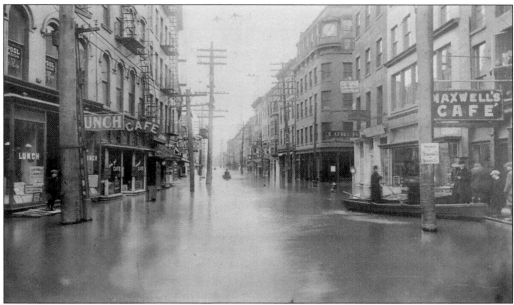

A VIEW OF THE FLOOD. This photograph showing Broadway and State Street during the Flood of 1936 was taken looking south along Broadway. The Albany Argus building is on right. The left portion of the photograph is now the site of the D&H Plaza.

A SINKING STEAMER, c. 1880. The first *Cornell* sank near Athens *c.* 1880. There were several steamer accidents over the years that claimed lives.

OOPS. A steam engine crashed into this building on the corner of Montgomery and Orange Streets *c.* 1880s. On February 25, 1866, a New York Central locomotive exploded near a crossing at Broadway, shattering nearby buildings and hurting four people, some of whom were thrown into the air.